Believing in Ourselves

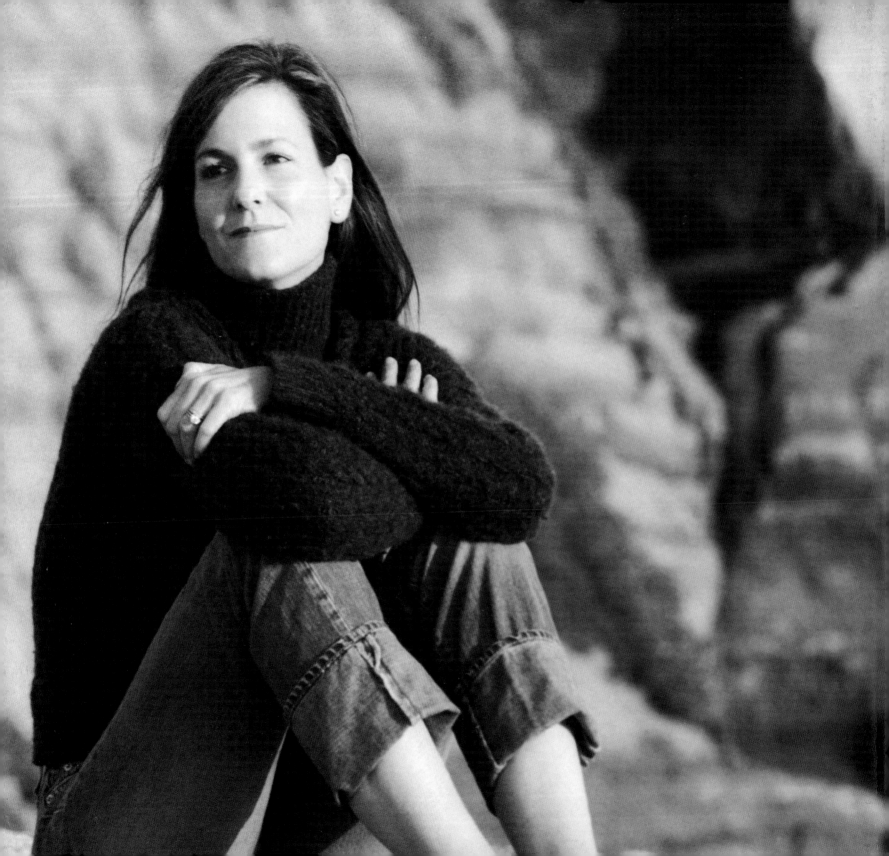

Believing in Ourselves

A Celebration of Women

NANCY CARSON

PHOTOGRAPHS BY JENNIFER JONES

Ariel Books

**Andrews McMeel
Publishing**

Kansas City

Photographs copyright © 2002 Jennifer Jones
Edited by Margaret Lannamann

Carson, Nancy, 1939–
 Believing in Ourselves : a celebration of women / Nancy Carson ; photographs
 by Jennifer Jones.
 p. cm
 ISBN 0–7407–2220–4
 1. Women—United States—Biography. 2. Women—Canada—Biography. 3.
Biography—20th century. 4. Successful people—United States—Biography. 5. Successful
people—Canada—Biography. I. Jones, Jennifer, 1968– II. Title.

CT3235 .C37 2002
920.72'0971—dc21 2001053301

Table of Contents

Preface

To write a book like this, I first had to think about why someone would read a book like this. Jennifer's exquisite photographs will catch the eye of the browsing reader; will my words catch the heart? Each woman in *Believing in Ourselves* has a history that no one else will live. What do we take from their experiences? And what does it mean to believe in ourselves?

Then I talked to the women and heard their stories.

All the women in this book drew upon deep strength to get through to the other side—for their community, their family, for people who needed help, and for themselves. By believing in themselves they not only made it through, they made it to a place of joy and wholeness. Some were always certain that they could realize their vision and they never hesitated; others went from stricken to unstoppable.

Every woman will encounter loss, grief, and profound difficulty. But happiness, achievement, and success are in front of us as well. The lesson of *Believing in Ourselves* is that despite what life gives us, and sometimes because of it, the rich, full life is possible. Each of us has the power to make this choice. The achievements of these women vary widely, but as people they have a common attribute. They decided who they were meant to be, and they became that person. They

lived their own life, not the life someone else defined for them. They stuck with it. They overcame poverty, sexism, racism, sickness, and pressure to conform. They focused. They absorbed the body blows of life and kept on going.

Along the way, they discovered that overcoming adversity leads to compassion and generosity. They give back in ways that greatly multiply what they have received. They are creators, artists, teachers, writers, doctors, athletes, mothers, entrepreneurs, lawyers, leaders—they are people who build a healthy world.

Women have always shared stories. We give each other strength for the journey, courage for the struggle, and hope for the future. When one of us reaches the other side, the rest of us realize that we can make it too. By their lives and their stories, the women in this book teach us to believe in ourselves. Read these wonderful stories, then go out and live your own.

—Nancy Carson

Note from the Photographer

These images form a collection of believers: a gathering of women guided by inspiration or driven by an instinct for survival, yet all fortified by their uncompromising passion. Though each journey is unique, the common threads of grace and perseverance weave them into a vibrant tapestry of twenty-first century role models.

I would like to express my deepest gratitude to all the women for their graciousness and courage in participating in this project. You all showed such willingness to share your tales of internal struggle and extraordinary transformation. Thank you for allowing me to capture these images with a transition so smooth the lens seemed all but unnoticeable. As the photographer, I faced the delicate challenge of being a stranger with a camera intruding into your lives, but I am left with not only complete admiration for your strength and spirit, but also profound inspiration. The comforting and compassionate bond of womanhood resonates throughout these pages.

I thank you, Margaret Lannamann, and everyone at Ariel Books, for your continuous support and, more important, for allowing these stories to be told; my family and friends for giving me support and encouragement; Sharon White and Bob Packert, my mentors from the beginning. And to you the viewer—for your ability to learn from both the near and the unfamiliar—thank you.

—*Jennifer Jones*

Note from the Editor

When the idea for *Believing in Ourselves* first took shape, I wasn't sure how to begin. How would I find thirty-five women with extraordinary stories to fill the pages? I began slowly, tentatively, using personal contacts, newspaper articles, and Internet research. Soon my search gathered momentum, and I discovered such a wealth of material that I could have filled ten books.

This process has been exciting, humbling, and deeply inspiring. I have had the opportunity to talk with some of the most extraordinary women I have ever come into contact with. In listening to so many amazing stories, I have learned how indomitable a woman's spirit can be, and how generously a woman's heart can give.

To all of you whose stories appear in this book, and to the many others who helped in countless ways, I offer my heartfelt thanks. Your words and your actions are an inspiration to us all.

—*Margaret Lannamann*

Believing in Ourselves

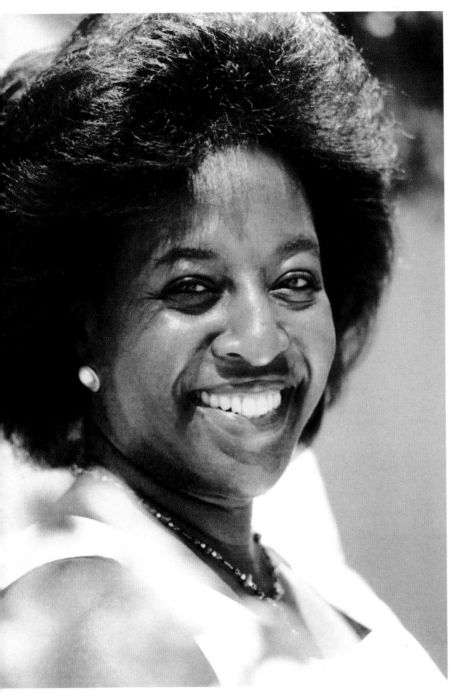

Claudia Edwards

I decided at that moment that nobody but me was going to determine my future.

Growing up in the Bronx, Claudia Edwards was an unmotivated learner. She graduated from high school, had a son at eighteen, and a second son three years later. But by the time her younger child was three years old—in fact, the day she first dropped him off at the day care center—she began a long struggle to claim a different life. Today, she is executive director of a Fortune 500 company foundation and a powerful role model. How did she do it? It started with Mr. Burg.

"Mr. Burg was my economics teacher in the eleventh grade, and he liked to predict people's future. One day, after telling one student he would be a lawyer and another that she would become a teacher, he said to me, 'Edwards, you'll be pushing a

baby carriage six months after graduation.' I was devastated, and worse, it came true. One evening the next year as I sat feeding my son, I remembered that remark, and I connected with my anger. I decided at that moment that nobody but me was going to determine my future or the future of my son."

Claudia learned of a new policy in the New York public colleges called "open enrollment." It allowed anyone to attend college and make up deficiencies as they learned. When her son started day care, she took a bus directly to a local community college and asked how she could enroll. By the next year, she was a student at Bronx Community College, and at age twenty-nine, she had completed the two-year program and received an associate arts degree. Embarrassed that she was so far behind, she skipped graduation, but now looks back on it as a major milestone, the point where she took control of her life. She was behind, but she had learned how to catch up.

"It took me thirteen years to obtain my associate, undergraduate, and graduate degrees. It was very difficult. I was a single parent, so I had to work and raise the boys and study. I took public transportation to my job at Columbia in Manhattan, to my evening class at Queens College, and back at night to my apartment in Co-op City. Mr. Burg's remarks kept me going when I was exhausted. I was determined to become somebody."

Claudia began to realize that she had to actively claim what she needed, and she incorporates this message when she speaks to young people today. "The second chance I got is out there for others. It's not about where you came from, and it's not about how long it might take for you to get where you are going. It's about seizing the opportunity to realize your potential, striving to be the best, and making sacrifices.

"My professional career began when I was enrolled at SUNY Purchase. I got a job as executive director of a nonprofit. It was low pay but I could work and go to school, and I learned the ins and outs of management. Soon I had a reputation as a good manager and a local advocate." Because of this success, Claudia was asked to develop state programs for housing the homeless. Her animation in describing this period of her career reveals that, as she combined education with powerful experience in community, she came into her own.

Along the way she realized that she had help—her "sister spirits." "Everyone needs friends who champion you along, and who have the courage to tell you when you are wrong. These women helped me buy my first home, and helped me with all my career moves. We need to bring others along with us on our journey.

"Partly from these women, I learned that it helped my career to move laterally. When I reached a ceiling in one organization, I moved to another, where I could continue to advance." Claudia eventually took the leadership of the Reader's Digest Foundation and developed a strategy to increase the presence of the foundation, especially in areas where the company employees lived. As the leader of a major foundation, Claudia has discovered that people sometimes assume she has a boarding school–Ivy League education. Attractive and soft-spoken, she does not telegraph to others the struggle that is behind her. "It's a reminder that achievers come from all walks of life."

Claudia has a special message for women. "Womanhood is something you claim and seize, not something you grow into. We are constantly positioned by society to be the support system for somebody; we are women in waiting. Make a decision about where you stand in life, and what you stand for, and if that does not meet the needs of others, do it anyway. They may kick and scream, but they will get over it, and they will respect you. How many of our dreams get stopped because our aspirations for ourselves do not meet those of the people we love? You can achieve and still be loved."

Susan Edwards-Bell

Think of a snow globe. It shows a perfect world. Now imagine the globe is knocked off the table. Everything shatters. In one moment, my perfect world was gone.

Susan Edwards-Bell's girlhood was charmed, like the perfect world of the snow globe. A beloved child in a happy family, Susan grew up playing tennis and softball, cheerleading, and hearing remarks about her beauty, especially her glorious hair. She was the California golden girl. Things got even better when Susan became a student at San Jose State, moved into the Alpha Phi sorority house, and began mastering journalism, her mother's craft.

The snow globe of Susan's life shattered in fall of 1985. During a routine gynecological exam, her doctor said she needed surgery to remove a cyst. He reassured Susan that cancer was not the concern. "Older women get ovarian cancer, not women who are twenty-one."

But the grapefruit-size cyst turned out to be stage two ovarian cancer, and one of her ovaries had to be removed. Susan's doctor, with tears in his eyes, told her that without chemotherapy, she might die.

"First I screamed," Susan recalls. "Then I just insisted that I would not have chemotherapy, I would not do anything, I would just keep on with things as they

were." Showing the stubbornness of youth, she refused to think about treatment. "At that time there was little information available, no support groups, no pretty wigs or nice hats. I was alone with this terrible future." But her perspective on life changed abruptly within two weeks, when two sorority sisters were killed in a car accident. "That night I called my mom and told her I was going to go ahead. I realized my mortality, and I wanted to live."

Chemotherapy began, and Susan made it to the sorority pledge dance. However, within two days, her hair began to fall out in the shower. A friend drove her home, and she spent the next six months in grueling treatments that were much more difficult than today's cancer regimen. Nausea and exhaustion were common, eating was impossible, and fever arrived without warning. She was transformed from someone with radiant health into "someone who looked like a skeleton; all bones and with dark circles under my eyes. My life became my childhood bedroom."

Susan's resolve to live out her life, plus the support of friends and family, gave her strength. "I counted the days until I could go back to school. I lost a year. Who can tell you how to deal with these things—when you are faced with it, you just get through it. You can be angry all your life, or you can choose to move forward."

The deep love of Susan's parents was sustaining. "I knew that it would be terrible for them if I wasn't around." Her parents were always upbeat and supportive. "When they returned from a trip and found me completely bald, they just said, 'What a beautiful head you have.' They were

always positive around me, but sometimes I would be in bed unable to get up, and I would hear them crying in the next room. So I just had to find the strength."

The Susan who returned to San Jose State was profoundly changed. "I learned that you can lose everything in a minute. Because of the cancer, I had to learn to be pretty on the inside. I went from someone with superficial interests to someone who does not care at all what people look like. I don't complain about my hair, my looks, or anything like that. I look for what I can do in life, and I am thankful for everything I have." Free of cancer for fifteen years, she values the treasures of daily life, like running on the beach.

Although her golden California life goes on, there is a new depth and passion to everything she does. For example, Susan has become an advocate for the homeless. "I can identify with the homeless, since I know that sometimes people lose everything, and it's not because they did something wrong. So many people think the homeless chose their way of life, or could just change it tomorrow. I know different."

At Christmas, Susan's husband, Bradford, joins her in bringing blankets and other gifts to people living in San Francisco's parks and streets. Year-round, she uses her professional skills as well as her life skills to help these men and women. As a staffing consultant, she knows a lot about finding work. While consulting for a major Bay Area high-technology firm, she convinced the company to support her cause. Four times a year, Susan and other company recruiters visit homeless shelters and help residents prepare résumés and identify possible employers. The recruiters offer advice

on job skills and interview techniques, and even provide stamped envelopes for mailing the résumés. "Self-esteem is so hard to recover; I know because I've been there. When I was in treatment, people avoided me because I looked strange. The people we helped with résumés are treated the same way—it's the stigma of homelessness. But many of them got interviews and several of them got jobs, and those are important steps back toward a normal life."

Capturing what has happened to her with her writer's gift for language, Susan puts it this way: "I have had two lifetimes: my life before cancer and my life after. My second life is the real one and I cherish it every day."

Lily Heyen Withrow

He was our son. We never considered giving him up, not ever.

Lily Heyen Withrow and her husband, Lew, wanted children. Lily pictured her family gathered around the Christmas tree, walks for ice-cream cones, and other scenes of parenthood. So she did not hesitate when she learned they could adopt a child from eastern Europe after communism collapsed. She and Lew journeyed to Bulgaria and found themselves at a grim, forbidding orphanage, asking if there were any children available. "They said there was one, Miko, a little boy about three, with rather big ears. When we saw him, we were sure we had found our destiny even though he was withdrawn and quiet. We knew if we just brought him home and loved him, everything would be fine."

The adoption process took more than a year, and when Lily returned to Bulgaria to pick up her new son—to be named Forest Dimiter Withrow—it began to dawn on her that love might not be enough.

"When I got him home he was essentially a wild ani-

mal. He was almost four and had not been taught to talk. He had no socialization, no impulse control, and no trust. Soon I was desperate for help and started taking him to local specialists. They told me I was just an anxious mother."

Through a woman who had adopted a child from Russia, Lily learned about reactive attachment disorder (RAD). "Miko had all the symptoms of RAD. I was relieved that Miko's problem had a diagnosis, and that I was not crazy. A local therapist arranged for a RAD expert from Colorado to come to California. We did a week of intensive attachment therapy and were trained to continue working with Miko.

"We learned that RAD children, like Miko, had never bonded with a mother in infancy. We would have to take him back to when he was an infant, and re-create that situation. He could only learn trust if he surrendered control and eventually bonded with me. The therapist explained that if he couldn't bond successfully with his mother, he would never bond to anyone, and the chances were good that he would become a charming sociopath.

"We had to restrain Miko, forcing him to remain in our laps, sometimes for hours at a time. Lew and I took turns. Miko would rage, kicking and screaming, trying to bite or scratch, using all his strength to try to escape. He had to accept that we were in control, and that we would not leave him, no matter what he did. It was completely exhausting and emotionally devastating. At one point we wondered if we were helping him or torturing him, but it was our only hope. We had to do it."

After the training session, the holding therapy con-

tinued at home, consuming Lily's time and energy. As the number of severely damaged children adopted from eastern Europe increased, Lily and Lew learned of adoptive parents who had finally given up, unable to cope with children so needy and destructive. Lew and Lily never considered this course. "My husband and I are very similar in values and ethics. We believe that when you take on a responsibility, it's yours, and you don't just give up when things get tough. Besides, this was our son."

After several months of holding therapy, something happened between Lily and Miko. "One day I was holding him and he was kicking, biting, and spitting. I suddenly felt his pain inside of me. Then we both started to cry. I held him and hugged him, and we were crying for each other. At that moment he came into my heart, and the love began." Progress was slow but real. One day Miko hurt himself and came running into the house screaming for Mom. Lily knew he had begun to trust her at last.

Miko continued to dominate the household. Although he was improving, the struggle was relentless. "We had no community, no family, no support, and no breaks. In the last nine years, Lew and I have had maybe seven days alone." Then things got worse. About a year after Miko arrived, Lew lost his job. "The stress was enormous, I could not go to work because someone had to care for this crazy kid. Lew decided to start his own business, which would take years to develop. When that finally got off the ground, I was diagnosed with cancer. For a year Lew had to do everything, support the family and at the same time take care of both Miko

and me. Many men would have walked away."

Lew and Lily stuck it out. Miko began to function more normally, showing signs of compassion, bringing Lily a toy, a pillow, or a wet washcloth when she was sick from chemotherapy. And Lily? "Cancer was the event that enabled me to truly experience joy. I was part of a therapy group of extraordinary women, all with serious illness, and I did some difficult personal work. It's not that things don't bug me. I work long hours, the house is a mess, Miko is all over the place and probably always will be—but every day I'm glad to be alive."

Lily had given up a highly paid career to adopt and care for Miko. Now she has the job she always wanted as a journalist. "I work for peanuts, but I love it." Miko, who is starting sixth grade, is emerging as a delightful boy. "He's in special classes for learning disabilities, but he's very smart and entertaining, and of course still wildly active. He runs me ragged, but that's who he is."

Lily and Miko and Lew do not have the Kodak-moment life she expected, they have something better—a family baptized by fire into love and commitment. And as Lily says, "Good things can come from struggle. When I have a whole day free, there is nothing I would rather do than be with my husband and my son."

Sonia Sotomayor

If you spend more time applying yourself than worrying about outcomes, you are bound to get a lot farther.

Judge Sonia Sotomayor, who sits on the U.S. Court of Appeals for the Second Circuit, has a résumé appropriate to her status. Editor of the *Yale Law Journal* and managing editor of the *Yale Studies in World Public Order,* she graduated from Princeton summa cum laude and was cowinner of the Pyne Honor Prize—an extraordinary honor awarded to the senior who has most clearly manifested excellent scholarship and effective support of the best interests of Princeton. Her résumé does not include the fact that Sonia grew up in a Puerto Rican family in a Bronx housing project. That may be as significant as her academic honors.

Incisive and completely in control of her courtroom, Sonia Sotomayor is also unpretentious. Her intellectual quickness and legal knowledge keep lawyers on their toes, and her caring for others is legendary. Sonia, a dynamic woman who conveys both depth and sparkle, is clear about the reason for her success.

"It's easy for me to say why I've accomplished so much; it's all because of my mother. My father died when I was nine, and Mommy raised us. We were the only family in the housing project with an *Encyclopedia Britannica.* Books were my mother's priority; they came before clothes. I was a student in law school before I could bring myself to mark a book—that's how precious books were to us."

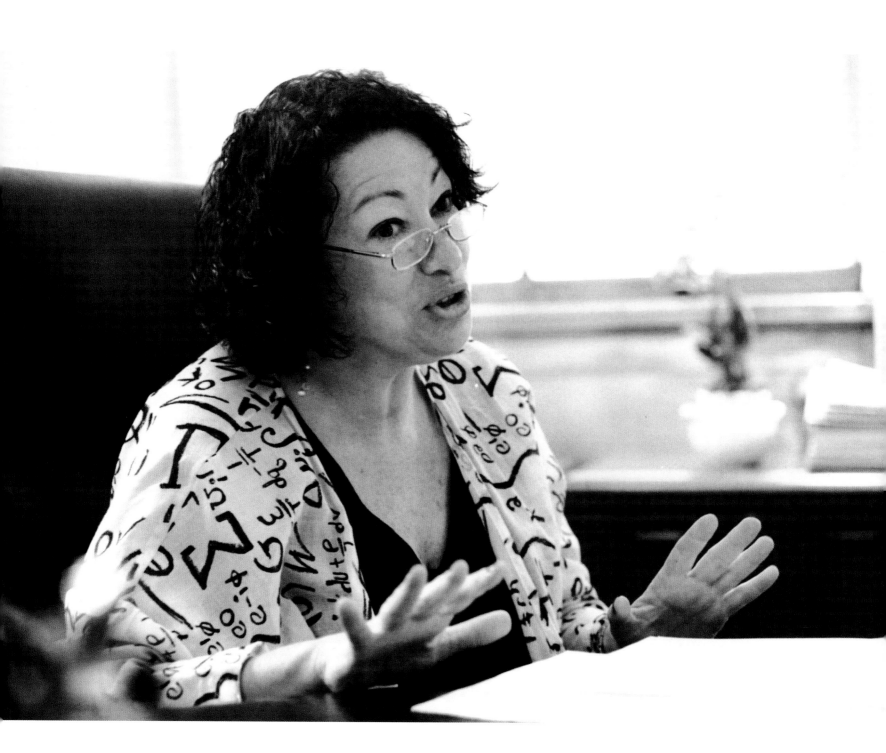

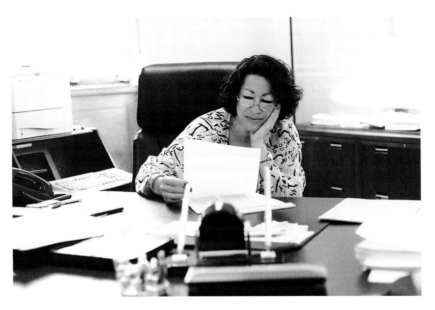

Sonia and her brother Juan, now a physician, learned from their mother that learning—for its own sake—was the most important thing in life. "She never tied learning to grades or achievement. Achievement was not the goal; it was the doing. She told us that we could do anything at all, including cleaning floors, as long as we did it well and with pride." Sonia's mother, Celina, worked in a Bronx hospital as a phone operator, and then became a practical nurse. "When I was a junior in high school, my mother sat down with my brother and me and talked about the future. She wanted to be independent after we left home, and asked if we would sacrifice now, so she could go to college and become a registered nurse. Of course we agreed. We all worked hard and she took out some loans. Mommy worked the hardest; she excelled at nursing school and passed all the parts of the exam on the first try. Within two years, she was the supervisor of the hospital emergency room. So, you can see, my brother and I had no choice but to do well."

With her mother's example and her own discipline and intelligence, Sonia excelled in Catholic schools. She expected to attend a public university, but a friend and mentor at Princeton encouraged her to apply to a private college. "The only thing I knew about the Ivy League schools was *Love Story*. I had no idea I could get financial help until my friend explained it to me; I attended on a full scholarship. When I arrived, it was very disorienting. I was an inner-city kid and Princeton is essentially rural. Mine was the third class that included women, and Latinas were scarce. I was definitely not the usual Princeton undergraduate. My classmates had traveled, read the classics, and lived lives I had known only in books. The summer after my freshman year I took the subway to Barnes and Noble, on Fifth Avenue, my first trip to a bookstore, to buy the classics, so I would know what everyone was talking about."

Sonia also bought basic grammar texts for grades one through eight, mastered the lessons, and expanded her vocabulary, so that her written

work would be the same as her peers', rather than English influenced by Spanish grammar.

Looking back, Sonia sees her life as a series of steps, each difficult but each rewarding. "It was always a positive experience. From my home to grammar school, where I learned to read well in English, then from my neighborhood to Cardinal Spellman High School in the northeast Bronx, where, for the first time, I was a minority, then Princeton—probably the biggest adjustment of all. After that, Yale, then the New York district attorney's office, practicing law at Pavia and Harcourt, the Southern District Court, and then the Second Circuit." According to family lore, at age ten, after seeing Perry Mason continually defer to the judge, Sonia concluded that sitting on the bench was the job for her.

Despite her distinguished career and excellent service as a district court judge, Sonia's nomination for the prestigious second circuit led to controversy. Opponents described Sonia as a likely "activist judge," subjecting her to bitter attacks on her alleged judicial philosophy. This led to a grueling eighteen-month wait for confirmation. Colleagues and supporters mobilized across political lines on her behalf, and she was finally confirmed just eight days before the deadline, after a frantic forty-eight-hour last-gasp effort.

Sonia's colleagues and friends believe that her future has no limits, and they testify that her generous nature matches her intellectual competence. The first Latina named to the United States Court of Appeals made this statement at her induction: "I have never perceived myself as poor because I have been rich in the most important things in life, the love, affection, and support of family, friends, and sometimes even strangers." She concluded her remarks by asking for the guidance and prayers of everyone in the courtroom. Next she performed her first official act— she married her mother, Celina Baez Sotomayor, to Omar Lopez, a man who had brought romance and happiness to Celina late in life. Then the salsa beat started and the party began.

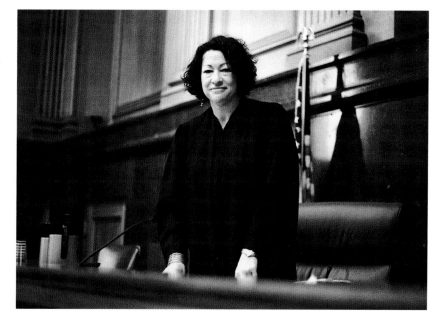

Beth Bakke Stenehjem

If I had another extra kidney, I'd donate to someone else.

Beth Bakke Stenehjem is sunshine, pure and unadulterated. She's often described as bubbly, happy, and positive. Her good friend and coworker Donna Iszler knew about Beth's willingness to help others, but even she was astounded when Beth decided to give Donna one of her kidneys.

"I worked with Donna at the North Dakota Vision Services School for the Blind in Grand Forks. I used to drive Donna to the office. Both of our husbands traveled, and if someone you like is the first person you talk to every morning, you really get to know them."

The more Beth got to know Donna, the more she liked and admired her. Beth is thirty-four and Donna, who has been blind since age eighteen, is now sixty-six. "I often say that Donna is the person I want to be when I grow up. She's taught music and Braille for over forty years, she never complains, and she's fun to be around." Beth, the librarian at the school, experienced her colleagues more like family than

coworkers. "It's a small group of people. We all worked closely together to provide services all over the state. I loved the job. When you get paid for doing service, what could be better?"

Beth knew that Donna was experiencing increasing difficulty because of her failing kidneys. In fact, Donna was performing self-dialysis four times a day. "She's blind, and this is a procedure that has to be completely sterile. But she managed it, just like she manages so many things. In August 2000, she went onto the list for kidney donation, and that usually means a three- to five-year wait. I began to think about giving her one of my kidneys. When she was sick for a few days, I realized that she could become much sicker before she got a kidney, and then I got serious."

In October, Beth stopped by her friend's house after work and said she would like to be a donor. "You know how women are. We talked about it and then we cried." Beth also informed her husband, Wayne Stenehjem. "Actually, I gave him the weekend to think about it, but he said, 'You're going to do this anyway, aren't you?' He did a little research on the safety of the procedure, and then he felt fine about it, and said he would do anything I needed to make this work." Wayne, who had served in the North Dakota legislature for many years, was in the middle of a campaign to become the state's attorney general.

Beth's next step was a trip to the Mayo Clinic to see if she could be Donna's kidney donor. The test results showed that Beth and Donna had different blood types. Even a couple of years ago this would have been an absolute bar to donation. But new procedures and the use of powerful antirejection drugs meant that Mayo could undertake the operation if both women wanted to try. "I went to a lot of meetings and got a lot of information. The people at Mayo wanted me to understand all about the procedures and all about the risks. One thing I learned was that you don't have to wait until someone is actually on the transplant list to donate; I could have done this much sooner."

On April 25, 2001, the Mayo surgeons removed one of Beth's kidneys and transferred it to Donna. This was the ninth nonmatching transplant performed at Mayo. "After ten, it goes from an experiment to a procedure." Beth had been told to expect to spend two to four days in the hospital, and then about three weeks recovering. "I'd never even been in the hospital or had any surgery, and I kept saying 'piece of cake' when people asked me if I was nervous. My boss said, 'no piece of cake.'"

The operation went extremely well for both women. "I admit that for the first three days I felt pretty sick, but I got over it. Because the opera-

tion was done as a laparoscopy, I only have a four-inch scar. The old operation required a large incision, and a much longer recovery.

"People came over to see me and help, my mom came, and my husband waited on me hand and foot. Everyone fussed over me. I received all these cards, many from people I don't even know. I'm not real comfortable with the media but we did interviews, because I want people to know that this is not such a big deal anymore." As predicted, Beth was her sunny self again after three weeks. Donna's recovery took longer, but she is thriving and free from dialysis.

Wayne was elected attorney general, so he and Beth have both moved to the state capital, Bismarck. She is working with the North Dakota Grain Growers Association. She misses Donna and her other friends at the School for the Blind, but is putting her energy into working for the farmers and encouraging people to become kidney donors. "If you are thinking about it, talk to the medical people to get more information, and then do it. You can save a life, or make someone's life so much better. It's really rewarding. I feel almost selfish, because I got back so much more than I gave."

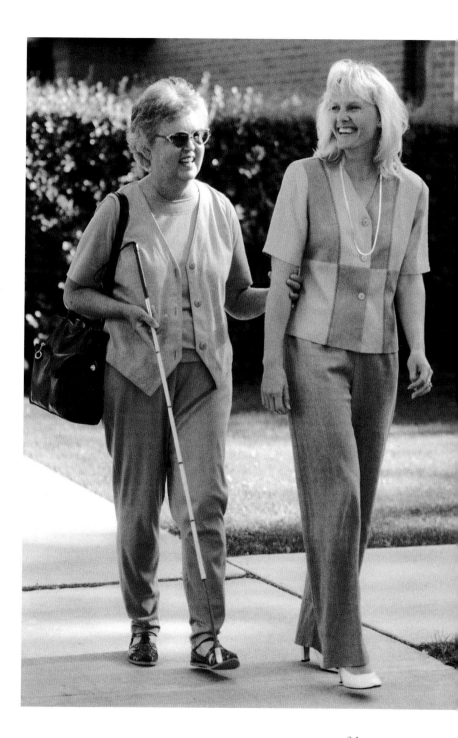

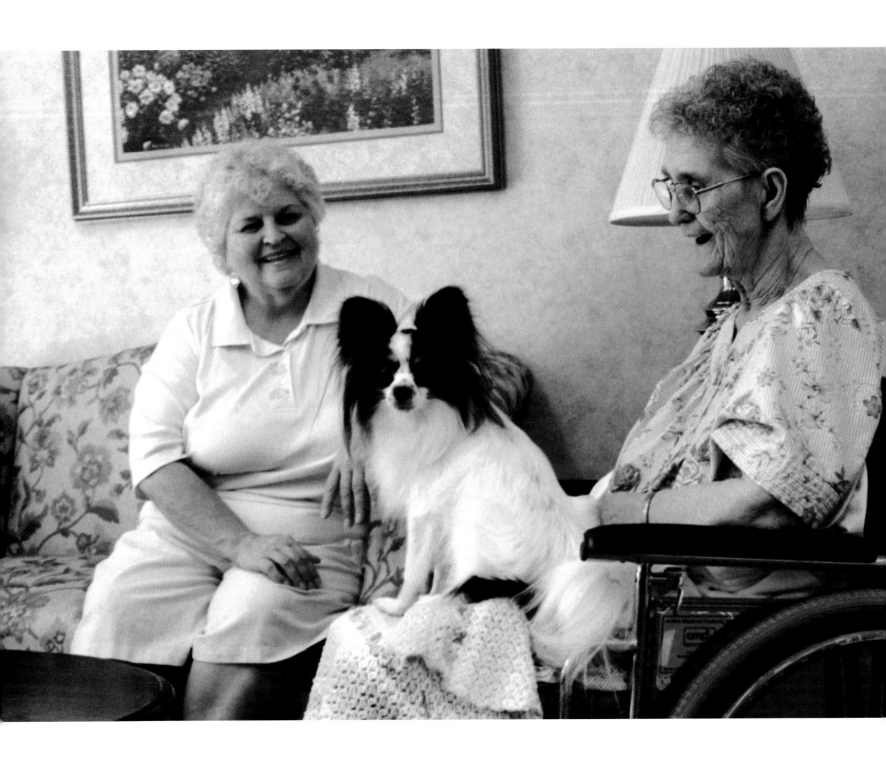

Barbara Cochens

I have time, I love to do new and different things,

and the animals make such a difference to these people.

Barbara Cochens brings a little bit of heaven to the elderly and ill in nursing homes near Sarasota, Florida. Pet therapy is the primary activity for Barbara and Hobe, Barbara's papillon, and she was providing this service long before it became popular. In fact, she did it before she knew it had a name.

"I had a Doberman who loved to go visiting. When I went to see a friend who lived in a nursing home, I took the dog along and everyone loved him. He gave them so much pleasure. After I got my first papillon, someone admired him at a dog show and said, 'You should do pet therapy.' I said, 'What's that?' and discovered it was what we'd been doing for years."

Barbara tests and certifies potential therapy animals. Dogs, cats, birds, ferrets, and other animals must be able to deal with strangers, sit quietly in a lap or next to a wheelchair, and cope with occasional loud noises. "Most pets pass the test. They have to sit, walk well on the leash, and interact with other animals. Right now we have about one hundred animals in the program—and soon we are adding a llama!" Recently, this active volunteer has been teaching obedience classes for puppies, and postadoption classes for Humane Society pets as well.

The positive effect of animals on the elderly is well documented, and Barbara has seen it many times. "On my first visit with Gizmo, my first official pet therapy dog, a woman who had not spoken for months wanted him on her lap. Gizmo liked to sit facing away from people. The woman became frustrated, red in the face, and wanted the dog to turn around. I told her to say his name. She tried and finally got out 'izmo.' He turned around and licked her face. It's not always this dramatic, but everyone responds in one way or another to the animals. And the dogs are so accepting. They understand."

Barbara's commitment springs from seeing the value of the visits, and from her own need to be productive. "I can't imagine anything worse than sitting home doing nothing. I probably get more pleasure than the people in the nursing homes. When we first moved here we didn't do this, and Gizmo got bored and lethargic. When we started back to work he became himself again, lively and energetic. It's good for the dogs, good for me, and good for the people waiting for their animal friends."

Mary-Lisa Orth

You tell me I can't and I'll show you I can.

Mary-Lisa Orth engineers defense systems; she is at ease in a man's field. But her engineer's skills of foresight, perseverance, and determination have been honed in a more familiar arena—creating a rich life for her family against great odds, including children with a degenerative illness.

"I never lose the long-term focus; that's what gets me through. And I'm stubborn. You tell me I can't and I'll show you I can."

Mary-Lisa's gentle manner and soft curls complement a steel will. Plenty of people told her, at crucial points in her life, "You can't." "You can'ts" included getting a degree while on welfare, working two jobs and going to school with four small children, completing a science degree as one of four women in a class of 109, and spending "tons of time" with her kids while leading a women's engineering group. And now, making sure her teenage twins live well as they cope with increasing obstacles.

Here's a snapshot of Mary-Lisa as a single mother, just out of high school. "I could have stayed on welfare until Rob was in school, and most people said I should do that. But I had self-respect, I wanted to learn, and I had a lot of energy. So I decided to get a practical skill. Every morning I took a bus and transferred twice to get to the baby-sitter, took another bus

to work, held down two jobs (tutoring in math and working in the library), and went to school full-time. I got my A.S. degree in mechanical engineering and we got off state aid within two years."

Marriage came soon, daughter Jennifer was born, and two years later Alexander and Benjamin arrived. "I washed diapers constantly. I went grocery shopping with one twin strapped in front, one in a backpack, Jennifer in the harness with a leash, and Rob running loose. Four kids was considered a lot, but if things had been different I would have had a dozen."

When the marriage ended, Mary-Lisa once again faced a "you can't" signpost. "I could either

work two jobs until the kids were out of the house or go back to school and make a better future. So I gritted my teeth and went back." She hired a live-in housekeeper, who also had a child, and organized the troops. "I wanted engineering as a career. I took one course at a time. I worked from 4:30 A.M. to 11:30, then took classes, went home in the afternoon, helped with the kids while the housekeeper went to school, studied, slept, then started over the next day."

Mary-Lisa regularly wrote down her life goals, and reread them when she was discouraged. "I always believed in education, and I wanted to be a good role model for my kids, to teach them to work hard and to make a good life. And I loved learning." The only woman in her class to graduate, Mary-Lisa received her B.S. in mathematical physics to the wild applause of thirty people—family, friends, and coworkers. The dean observed, "You have your own cheering section."

The degree brought a raise in pay, a promotion, and an opportunity to move to Tucson, Arizona. "Life was great. The company offered me an on-site master's program (systems and industrial engineering), we had a little house in the country, I had time to do things with the kids." Mary-Lisa, who believes "there is nothing you can't learn by picking up a book," taught herself knitting, auto repair, sewing, and anything else she wanted to

master. "I had a great job at Raytheon working with the engineering of cruise missiles. I was active in the Tucson Society of Women Engineers. I traveled for work and met fascinating people. I finally got my dream car, a Chevy Suburban. My license plate read, 'As Good As It Gets.'"

But in fall of 1999, as the twins were starting their senior year of high school, Mary-Lisa noticed one of them holding on to furniture as he crossed the room. Weeks of tests led to a diagnosis of Frederich's Ataxia, an extremely rare disease of the spinal cord and the cerebellum, for which no cure has yet been found. The disease is genetic, so both twins are affected.

"First I cried for three days. Then I made a plan. We had to move immediately to a wheelchair-compatible house. My friends from work came over and moved us, and I shifted my schedule to four ten-hour days a week. Now I keep Friday free for doctor visits and everything else we need, plus my personal nervous breakdowns."

Ironically, Mary-Lisa is back in a familiar situation. "If I quit work and went on welfare, we'd be better off financially because of the medical costs, but we need to look at the long term." Time with the kids is even more precious, work in the community "contributes to my sanity," and an on-line support group for Frederich's Ataxia connects her with other parents facing the same challenge. The twins have friends over every weekend, so the house is lively (and the refrigerator is full). "I try to take care of myself. I read half an hour every night, go to the gym, walk the dog, spend time with girlfriends every two weeks, and keep a handwork project going." And Mary-Lisa has a crop of crabgrass in the lawn, for those times when frustration mounts. "Sometimes," says this engineer, "there is nothing like grabbing two handfuls of crabgrass and pulling."

Ann Steiner

I find ways to do things I thought I could not. I don't postpone joy.

For many years, Ann Steiner could not move without pain or hold a book to read. In addition to coping with her medical condition, she struggled to conceal it, always trying to fit in, to be accepted as "normal." Today she sees her future as bright and unlimited. She took charge of her illness and learned to manage it, relying on the best medical information and a decision to cope with some pain to enjoy life. The first clue to the new Ann may have been when she wrote "Wheels of Liberation" on the back of her electric wheelchair.

"I've had severe arthritis all my life. It was not properly diagnosed for many years. As a teenager I was taking sixteen Ascriptin a day and wearing orthopedic shoes, but I once did a long-distance bike ride. I had a lot of denial of my own experience."

As Ann grew up, her family continually supported her. "A great gift from my parents was their belief system. Figure out what you want and work hard for it. It won't be easy, but don't give up." When Ann's high school failed her, her parents found another. When her doctor said no college, they found a doctor who could work with Ann to build a future.

"With a lot of pain and adjusting, I made it through college and graduate school, but I was still in denial. I would look at an obstacle and figure out how to manage it without asking for help or revealing how hard it was for me. I developed a crude pain/price index—what is really important to me, what will it cost to accomplish it? Is a dance class worth several days of pain and being unable to walk more than a car length?"

Today, the woman who struggled to hide her difficulty is Dr. Ann Steiner, a faculty member at a major university, a keynote speaker at national conferences, an author, and a psychotherapist in private practice. Sitting in her well-loved flower garden, Ann reflects on her early struggles. A woman with a regal smile and calm manner, she observes that she let her condition define her life for too long.

"When I began my practice, my mobility was extremely limited. I was under the care of a doctor whose treatment made me more and more disabled. I had faith in this man. He said more bed rest, monthly injections, more medications. I was scared, and I adapted to illness too well. My father designed a bed for me with the stereo and telephone within easy reach, and I used talking books. I clung to beauty—I had a hydroponic garden to grow tomatoes—but my world was shrinking."

Ann's zest for life did not go to bed, however, and when a boyfriend suggested she get a wheelchair so she could join him at the car races, she finally agreed. "This was a painful decision.

My biggest struggle had been to not be seen as needy or dependent. But the chair got me out. Now I could go places, although I hated it when people fussed over me. That's why I wrote 'Wheels of Liberation' on the back of the chair. So people would understand that the chair gave me freedom."

At about this time, Ann heeded her parents' concern and agreed to consult with a new doctor. "The doctor was horrified at the drugs I was taking. He said I was clinically debilitated and addicted to steroids and painkillers, I had to stop smoking and eating chocolate, I had to lose weight. He changed my medication to something I could taper off. And he gave me hope. He said there would be some suffering, but it could be minimized and managed. I was fearful of change, but I had already given up so much I loved. What did I have to lose?"

Working with the new doctor, Ann reduced the drugs and started exercise. "The first rebuilding was to walk in the swimming pool for five minutes. It was painful, frustrating, and embarrassing, but I did it." After the pool came short walks, a class to quit smoking, a low-fat diet, more exercise. She refused to give up, even though progress was slow.

About a year into her recovery, she was asked to travel across the country for a nominating session of the American Orthopsychiatric Association. "I said, 'I can't go' but a friend said, 'of course you can.' So I did it. I flew to New York, rented a folding electric wheelchair, stayed on my own, went to the Metropolitan Museum, and met relatives I had never known. I had learned to ask for help when I needed it, and the entire world opened to me."

The open world brought personal and professional rewards. Ann's therapy practice is thriving. Many patients have no idea of her medical history. For others, her personal experience is powerful. She carries a full schedule of lectures and group work to help others with chronic illness live a full life. Her own pain/price index is now a sophisticated tool that she shares freely. "I am an outspoken patient advocate who believes strongly in the importance of empowering ourselves, getting the best possible medical care, and living a close to normal life.

"Life is exciting. There aren't enough hours in the day. I have setbacks, and I will always have to calculate what I want to do against what it will cost. But I have more passion and energy than I have ever had, and there is so much beauty in my life. I often find myself saying to patients something I saw on a huge poster when I started to travel. I got a photograph of the poster and kept it on my desk as I began to heal. The words were 'Don't postpone joy.'"

Antonia Novello

I spent at least two weeks every summer in the hospital, and I thought doctors and teachers were the best people on earth.

Antonia Novello endured chronic illness as a little girl in Puerto Rico. Adversity, successfully overcome, can plant the seeds of achievement. Antonia's admiration for her doctors led her to study medicine with a focus on children. Mobilizing her intelligence, willingness to work hard, and political skill, Dr. Novello rose through the medical profession and became the person responsible for the health of all the nation's children as well as adults—the surgeon general of the United States.

After attending medical school in Puerto Rico, Antonia moved far north to the University of Michigan for her internship. "I was one of four entering women and the only Hispanic. Of course, in their eyes, I was different, but I never let people make me feel bad for what I can't control. If you go somewhere with a chip on your shoulder, they just bust the chip." Antonia was named Intern of the Year and relished the competitive environment, which allowed her to succeed based on merit.

"I learned to compete early. My mother was my seventh-grade math

teacher, and once she gave an unannounced quiz and I got a C. She made the class sit by rows based on grades, and I had to sit in the C row. You bet I studied." Antonia's mother, now seventy-eight, continues to demand excellence as a junior high school principal. She taught her children that they could and would achieve; it was all about effort. "She told me I could do anything, be anybody. When I told her I had been accepted to medical school, she told me not to worry as long as there was a bank that would loan us money. I was going to be a doctor."

Antonia specialized in pediatric nephrology (kidney function), constantly striving to be the best physician she could be, and became increasingly committed to serving the health needs of people without power or resources. To accomplish this goal, she entered the U.S. Public Health Service in 1978. Antonia served at the National Institutes of Health (NIH), and eventually became deputy director of the National Institute of Child Health and Human Development. She mastered strategy and politics, as well as research and health care administration, along the way.

One of the first people to call attention to pediatric AIDS, Antonia fought hard for funds and awareness. "People refused to believe that this disease was affecting women and children. There were times when I had to call reporters and blast them out of their complacency. At that time, AIDS was the leading cause of death for children under five. Eventually I was able to convince Congress to give the institute $50 million directly; this was the first money we did not have to beg, borrow, or steal from another program. At the appropriations hearing, Congressman Silvio Conti thanked me for my testimony and said it was a pleasure to find an Italian woman so dedicated. I thanked him back. With that kind of money, I was not about to correct him to say that my Italian side came by marriage, while my guts were Puerto Rican."

Another achievement at NIH was the Task Force for Women's Health. For years, clinical study directors and researchers had developed data on males, and extrapolated the data to make medical

conclusions about females. "We said that if you are going to prescribe and treat women, they must be studied equally with men. At first it was hard to convince the medical establishment of this. Finally we won." The women's task force also produced a book identifying and describing senior women government scientists. This book went to every depository library as a reminder of the importance and value of women in science.

"I believe my work as chair of the Pediatric Task Force was probably what put me into the field for the surgeon general job. As a member of the Public Health Service, I was a career employee, so I was absolutely stunned when the president selected me." In 1989, President Bush nominated Dr. Novello as surgeon general, the first woman and the first Hispanic. The surgeon general is the nation's head doctor, advising the president and Congress on policy for all health matters and directing the 6,100 members of the Public Health Services Commissioned Corps.

Her proudest achievements as surgeon general were raising awareness about AIDS (including facts about clean syringes and essential elements of prevention), waging a vigorous campaign against underage drinking, following up on women's health issues, and initiating a massive effort to make children healthy as they begin school. "The United States went from having 87 percent to having 95 percent of children fully vaccinated before they began school because of this great public health effort."

After the Bush administration, Antonia championed the needy of the entire world as UNICEF special representative for health and nutrition. She assisted in the global effort to eliminate iodine and vitamin deficiency disorders, immunize children, and prevent smoking in young people. In 1999, she became New York State health commissioner. As a leader in the medical world, Antonia continues to push for improvement in basic health care. "We must find a way to provide health insurance for all the children, including oral and mental health. When all the children of the nation, no matter their background, have comprehensive health coverage, I will feel better."

Antonia Novello is accomplished, sensitive, focused, and unflagging. She believes that women too often hesitate to seize an opportunity because of their cultural background. "Almost any job can be done if you have the chutzpah to learn, and the wisdom to ask for help. You need both. Share knowledge, and delegate with trust. When you find that a job offer and your heart have come together, then that is the job for you. You can and will be able to do it."

Lilly Jaffe

*I am more happy and fulfilled than at any time in
my life.*

Lilly Jaffe has lived the life of the seeker and the artist, deeply introspective and
at the same time fully engaged in the world. The life that leads to wholeness.

After emigrating as a child from Vienna, she lived in Philadelphia and New
York, and eventually married. An early manifestation of Lilly's nature as a seeker
came in 1944. "I had visited San Francisco, my husband's home, and I decided we
should move there. I sold everything, gave up a wonderful job at an avant-garde
newspaper, and an art school scholarship. I had an intuitive feeling that we
should go, and over time I learned to follow my instincts."

She found the perfect job in San Francisco as a curator at the Palace of the
Legion of Honor Museum. Lilly created a program for the San Francisco schools
that correlated art with every aspect of the curriculum, using slides and pieces
from the museum collection to show students how art related to their entire
world. She led Saturday art programs for children and adults, and observed
that art could be used for therapeutic purposes. She wondered about incorporating
this insight into her life. In the 1940s, art had been taught piecemeal, if at all.
"I wanted to show my students that art was comprehensive, that it extended and
related to all of their experience."

As Lilly worked to expand others' appreciation for art, she also worked to understand herself. "I realized there were thoughts and other things happening inside of me that I never shared, because they seemed inexplicable, even when I was young. I had no name for this; people did not talk about it. I did classic Freudian analysis, and other kinds of therapy. I read. I became steeped in the literature of psychotherapy."

Lilly's artist's eye led her to the next discovery. "In 1959, I went to the San Francisco Museum of Modern Art and in their shop I saw the most delightful little carvings. They were enchanting. I learned they were from the Arctic, done by the Inuit." Lilly had discovered the artistic beauty and value of Inuit art before it was generally acknowledged by the art world. "I asked when more pieces might come, and they told me possibly never. I still had connections at the Legion of Honor, so I went to the curators there to try to find the source. After about six months and dozens of phone calls, I found a man in the Midwest who was importing Inuit art for sale in the states. I visited him and bought those pieces that appealed to me. I planned to keep some for myself and sell some to my friends. The pieces included sculptures, some stone-cut graphics, and some printed with sealskin stencils. Everything I brought back from this trip that I was willing to sell was snapped up right away. I ordered a larger selection of the new yearly editions and began to exhibit the art in San Francisco and the western states.

"Eventually the department of anthropology at UC Berkeley contacted me about exhibiting my collection. A well-known expert who had studied the people, language, and culture of the Arctic offered to meet with me and let me visit while he and his wife spent a year living among and studying the Inuit culture." Lilly accompanied the anthropologist to several Inuit settlements in the Hudson Bay area. On her visit Lilly asked about tribal myths and experience. One of the carvers told Lilly how as a child he had found a mermaid and held her in his hand. "He was so distressed because he had touched the mermaid, and she died. As an adult he remembered her tiny sounds. These people still lived their ancient stories." The carver drew Lilly a picture of the mermaid, which hangs in her home today. Lilly helped the Inuit sell their art internationally, introducing them to the outside without commercialization.

"When things began to change in San Francisco during the sixties, I spent a lot of time at Esalen." The Esalen Institute, in Big Sur, was ground zero for new awareness, new approaches, and experimentation. Lilly took advantage of the energy and opportunity to explore what Esalen offered.

"After my husband died I moved with my daughter to Vancouver, B.C., to be in a new place and a new atmosphere. I took workshops at the Cold Mountain Institute, on Cortez Island, which was modeled after Esalen. The founder asked if I would like to try working with art. People were just beginning to use art as a tool for increased self-awareness. As a direct result of my experiences at Esalen I came to the conclusion that art was closely connected with self-awareness and personal growth. I was there for ten years doing workshops and training people in this branch of the growth movement."

Lilly had become a founding member of the British Columbia Art Therapy Association, training and influencing hundreds of people. "I continued to do workshops and see clients privately until 1992, when I had open-heart surgery." Although she stopped taking clients, she never stopped exploring.

"I was fortunate to find my soul mate in Clem, my life partner. He has enriched my life for the last twenty years. I have friends who read to me, because I can barely see, and we share interests. I continue to learn. Another great boon to my life is that I was involved with the therapeutic process, doing it myself as well as with clients. Because of that, I learned much and became spiritually aware. Now I am able to do very little, but I feel somehow rich inside."

Lilly has achieved the Zen objective—living in the moment. "My life is no longer fractured. I may live a few more days, or a few more years. It doesn't seem to matter very much. I live in the present. I meditate. My inner life is expanding. I feel whole."

Karen Lundgren

Let's do it! Let's go fast!

"Let's do it" is a familiar remark, but this particular quote is Karen Lundgren urging her teammates to lower their tiny boat into a snake-infested jungle river, so they can paddle into the night without sleep and try to win Eco-Challenge Borneo. Karen's day job is with an educational consulting firm, but her true identity is adventure racer.

"Adventure racing asks everything of an individual, both in fitness and in teamwork," says Karen. "I love this sport. You have to be mentally strong, and of course you have to train almost constantly to be physically strong. You can't imagine how much fun it is." In an Eco-Challenge event, teams of four cover about three hundred miles of rugged terrain by hiking, biking, swimming, rock climbing, kayaking, and anything else that works. Each team must include at least one woman, and the entire team must finish to win. If any member cannot go on, the team is out.

Karen grew up in an athletic family. "We skied and did outdoor sports, but it was just for fun. I'm the one that got the competitive gene—I'm like the family problem child. They are used to me now and my nieces and nephews love to see me on television."

After college Karen found herself in Big Bear, California, where friends invited her to join them racing mountain bikes. "The first year I went from beginner to expert, and I was thinking of turning pro. Then I did a three-hour adventure race with friends—paddling, biking, and running. I loved it. I knew this was my sport. My friend Paul and I decided to train over the winter and look for races. We both worked weekends at a ski area, where I still coach the little kids' ski team.

"We were learning about the sport when Paul saw an application on the Internet for Eco-

Challenge. I didn't know exactly what that was, but it was the last day to enter, so I filled out the form and sent it in. I made up two names, because it was only Paul and me and we needed four for a team. That was Friday, and on Monday we got a call asking if we really wanted to go to Eco-Challenge Morocco. That year they picked one team by lottery, and they had picked us. I said, 'Where's Morocco?' So we had from the beginning of March to October to find teammates and train. We finished eighth in Morocco, and they called us the 'Cinderella Team.'"

Most adventure racing teams train for years before even qualifying for a major race. "Being on a team is one of the coolest parts, and one of the hardest. It's like working: You have to get along with each other, and you are going to be really, really tired and stressed. It's who I am, not who I want you to think I am. After a race you either love the people or you don't race with them again.

The winning team is not the fastest, it's the team who deals best with crisis, the team that can get through it."

In the Borneo race, leeches, exhaustion, mud, and mountains all played a big part in testing the teams. Injuries, blisters, and swollen feet had to be overlooked. The teams made do with food they carried and water they found. After a costly mistake on the first day, Karen's team—Team Hi-Tec—fell behind, but caught up to finish tenth.

On the race course, and in day-to-day life, Karen is positive, energetic, and full of zest for life. "Being a woman in adventure racing, I am asked to be on a lot of teams. You are out there for seven days or so, and you have to master all the skills. The people who are good at this are not the supermacho guys or the girly girls, they are the people who can move toward the middle, who can sit on their egos and take help when they need it, so the team can go on. It can be the hardest thing of all to ask for help."

Part of the fun for Karen is talking to kids, and especially encouraging girls into sports. "There is nothing better for their self-esteem. Athletes don't go through that whole thing about worrying about how they look, they just want to be strong, and self-confidence is the result. I speak at schools whenever I can. The kids always want to know where we go to the bathroom, why we do this sport, and what it's like not to sleep.

"I explain to them that it's amazing what your body can do, you just deal with it. In this sport experience counts for a lot and you can keep up your stamina with training. One of the things we like to do around here is run as fast as we can up San Gorgonio Mountain. It's 11,499 feet. One team went from the trailhead to the top and back in seven hours; our record is three hours and thirty-three minutes! On another weekend I might do a distance ride on my bike and then paddle around the lake. It becomes your life if you love it. I am never going to quit."

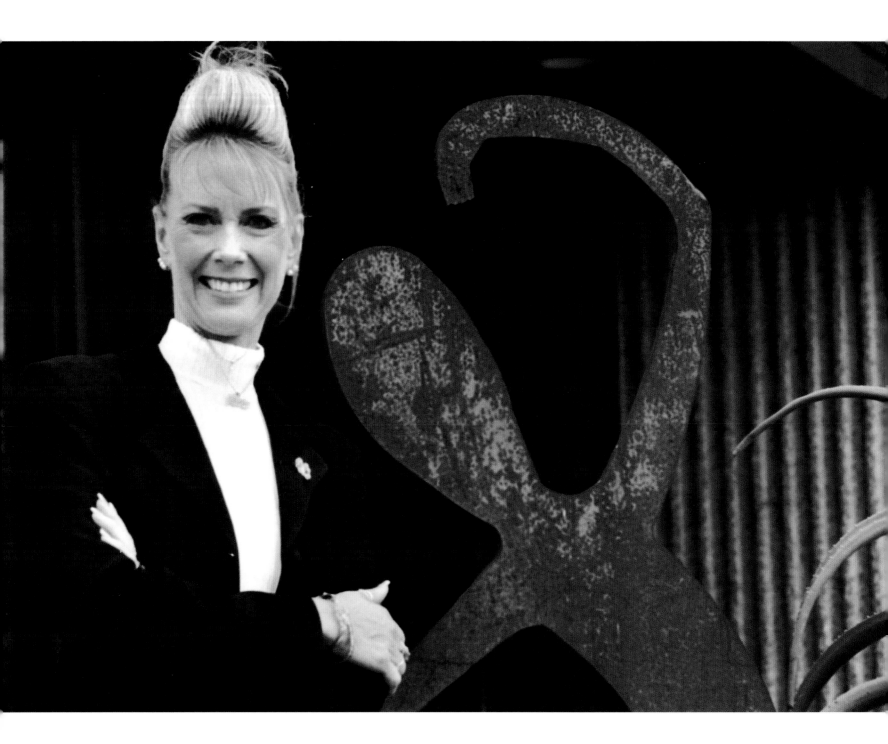

Judi Sheppard Missett

If you are passionate about what you do, it never seems like work.

As a professional dancer, Judi Sheppard Missett knew why she loved what she did. Dance gave her energy and a positive outlook, the joy of movement gave physical expression to emotions, and the discipline required for dance helped Judi accomplish her goals. She wanted to share all this, but when she finished college and started teaching dance classes in Illinois in 1969, she found that women started class with enthusiasm but did not stick with it. "I knew what they were looking for. If you move every day you will move through your life in a much more positive way, you will take risks and chances and be spontaneous. But these women did a few classes and then just never came back."

Judi soon realized that the women who came to the studio were amateurs, and she was teaching them the way she had been taught—as a professional. Judi trusted her instincts and made a radical change.

"I turned my students away from the mirror and had them look at me. I became their mirror. I choreographed high-energy routines that were not too difficult, and I used music that was exciting and emphasized the beat. Now the students didn't have to learn complicated steps, it was more like follow-the-leader, and when they did it right I told them how great they looked."

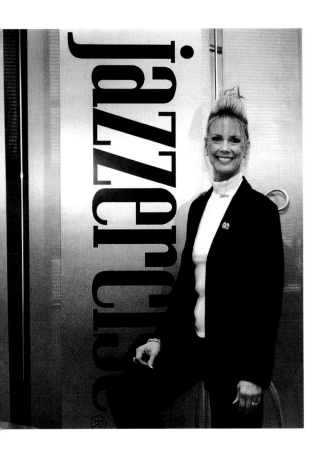

Judi had cracked the code. Suddenly her students were laughing and having fun—they were dancing! Demand for classes doubled. Judi generated more routines, more fun, more joy of movement. Her insight had given birth to what would eventually become the world's largest dance fitness program—Jazzercise, which today has over 5,000 franchised instructors and has served more than fifteen million people.

But the road from that Illinois studio to an international presence was bumpy. People did not always want to take "that little exercise girl" seriously. "At one point I was running classes through a local recreation program, generating income for the city and myself, and suddenly the checks stopped coming. The director told me I was not a professional, and I was not entitled to make this much money. I stood up to him. I gave him a week and then told him I was going to the newspaper if I wasn't paid. My check came at four P.M."

Judi's can-do attitude reflects her midwestern work ethic, and a confidence that began with her mother. "My mother always told me I could do anything I wanted, and I never, ever in my whole life remember thinking I could not do something because I'm a girl."

The timing of Judi's new approach was excellent—Jazzercise turned out to be the leading edge of the fitness revolution. "At that time, people were not talking about women being fit, but the basics were really the same. Women wanted to have fun, get some energy, and improve their shape. We've added more emphasis on health and fitness as we've learned more, but that just makes the program better and better."

As the demand for Jazzercise skyrocketed, Judi realized that teaching with a few friends and former students could not meet the need. With extraordinary vision, she created a franchise-based program that would send Jazzercise across the country and, eventually, around the globe. "I knew that we would need high standards, and a way to maintain quality. We were the first aerobics program to franchise fitness instructors, and along the way we created the first industry teaching

standards. I continued to create new routines (thirty new routines still come out every ten weeks), and we pioneered the use of videotapes for instructor training. Not only has the business been a success, but hundreds of women have been successful as entrepreneurs through Jazzercise. Providing a business opportunity for women is one of the parts of my work that is most important to me."

Today Judi is widely known as the founder and chief executive officer of Jazzercise, Inc. President Reagan honored her at the 1986 White House Conference on Women in Business, and in 1988 she was named Entrepreneur of the Year by *Working Woman* magazine. From her Carlsbad, California, headquarters, Judi oversees a corporation grossing close to $20 million annually, and directs corporate alliances and related businesses such as exercise clothing and music. Her husband, Jack, runs the video division of Jazzercise, Inc., and daughter Shanna is responsible for international activities, managing more than 850 franchises in 38 countries.

Trim, lively, and photogenic, Judi still loves leading classes and traveling all around to promote fitness. At the 1996 Jazz Dance World Congress in Washington, D.C., Judi led a Jazzercise class of 600 in the Kennedy Center. "It was a chance of a lifetime and an experience that will forever be a shining star in my memory."

Although Judi Sheppard Missett is a celebrity, she is still anchored by the discipline and drive of a dancer. "Physical movement gives me the energy I need for everyday life. Like everyone, I have personal and professional challenges, and I draw on dancing and activity to keep me going. Going outside for a walk reminds me there are bigger, mightier things around us, and helps me keep my perspective. And I know that if you find work you love and keep at it, and keep trying what you believe to be right, you will be successful. Just look at what grew out of turning my students away from the mirror."

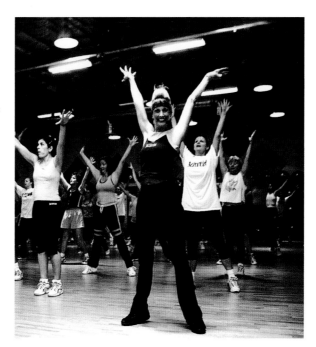

Frances Price

I would rather have fifty thousand blessings than fifty thousand dollars.

Frances Price's modest home in eastside Savannah is full of plants, sunlight, love, and children. Frances has already raised one family, but these days she is raising a second—her grandchildren. Whitney, Kevin, Derlisa, and Antonio are soaking up the warmth that Frances radiates.

Frances Price is a force of nature. She embodies a strong faith in God, a life-long Christian practice of loving and teaching love, and a commitment to her family. She has struggled to learn throughout her life. She volunteers to help people around her build better lives. And now Frances has taken in her four grandchildren while their parents try to overcome difficulties that have taken them away from their children.

"I kept praying, and I knew that God did not bring me through serious illness a couple of years ago for nothing. I stand on Hebrews 11:1: *Now faith is the substance of things hoped for, the evidence of things not seen.* It has truly been a blessing for me to raise these children."

Caring for four children is never easy, however, and Frances often grows tired, especially since her health is delicate. But there is a special satisfaction in doing this that stems from Frances's own childhood. "My grandmother didn't

show me love. In fact, she didn't like me, and sometimes said I was a bad person. I think grandparents and grandchildren should have a special bond, so I always knew that I wanted to take extra care of my grandchildren when my turn came." Frances was rescued from a forlorn childhood by her godmother, Lovelace Robinson. "She taught me how to be a woman, a wife, and a mother. I was always able to talk to her, and from her I learned forgiveness. She brought me through the pain. Because she stepped in and took over with me, I can step in and take over with these children."

When the grandchildren moved in with Frances, the cost seemed overwhelming. No one came forward to help. Then Frances connected with a local organization, Grandparents Raising Grandchildren, made up of a group of others who shared her situation. In Georgia, grandparents who take in children without going through the court system are not eligible for the financial assistance available to foster parents. Frances and other members of the group are lobbying to change this. Once she joined the group, Frances was able to purchase food at Second Harvest Food Bank, so she could feed four growing children with less financial strain. "A church group helps out at Thanksgiving, and at Christmas groceries and toys arrive from the Salvation Army. I know

we can do this. My husband, John, is my backbone, and he will not let me down."

Helping others is a habit for Frances. "I have a small ministry of visiting the sick and the elderly, and if I hear of a family in need, I try to fill their pantry. When I was very young I was told by my pastor that the way to be a good Christian was to help somebody. I would rather have fifty thousand blessings than fifty thousand dollars. I know that if I do what God asks of me, I will have blessings that I do not even know."

Frances has been a special blessing to people who want to own a home but who cannot qualify for a standard mortgage. A few years ago she was certified as a Federal Housing Counselor, and she volunteers her time to teach people how to repair their credit, organize their finances, and apply to home ownership programs. "It's hard for anybody today to have excellent credit, but for what most people pay in rent they could own their own home, if they only know how. I enjoy helping people find out how to do this."

Through her life, Frances has worked hard and never given in to despair or cynicism. As she says, "When there is no hope, reach up and grab the rope and keep climbing. Don't look back. I worked three jobs a day for twenty years to raise my children. At thirty-three, I went to school and became the first woman heavy-equipment opera-

tor and asphalt paver around here—we built the Chesapeake Bay Tunnel. At forty, I went to school and got a degree in banking and finance. Doors always opened for me." At one time she taught kindergarten. "When the children would argue and fuss, I would make them hug one another, because love will heal all wounds. So many children today have so much anger because no one loved them. In my neighborhood, if I see a fight, I go out and stop it."

Frances expects that the children will return to their own homes before long, but they will always be close to her and welcome. She is fearless about their future, and her own. Just as Frances trusts that the children will prosper, she knows she will continue to minister to others in her community. "It's not about me, it's about Jesus. I love people and I love the Lord. You got to believe in yourself. As long as I'm alive, I have hope."

Nancy Huynh

*I knocked on the laboratory door and said I wanted to learn,
then I showed up and proved it. So they put me on the research team.*

When Nancy Huynh began studying biology as a high school sophomore in Alhambra, California, she was instantly fascinated. "I wanted to know more, and my teacher suggested I try to work in a research lab. I was scared but I was eager, so I literally traveled around the L.A. area knocking on doors until I came to a lab at the medical school at the University of Southern California. They said yes."

Drs. David Horwitz and Dixon Gray recognized the scholar in Nancy and became her mentors. With their guidance, Nancy explored an aspect of lupus, an autoimmune disorder, and her project made her a finalist in the prestigious Intel Science Talent Search for 1999–2000 at age seventeen. The three coauthored a paper on their findings that Nancy has presented at scientific meetings; the paper will appear in the *Journal of Immunology.*

Intellectual curiosity and a flair for lab research often characterize a student whose parents are academics. Nancy's parents have a passion for knowledge but a very different history. In the early 1980s, they emigrated from Vietnam; her father is a construction worker and her mother has raised the five Huynh children. "My parents have a real love of learning.

They took us to the library so we could devour all the books, and they tried to explain everything we came across." Nancy was coeditor of the high school newspaper and a member of the track team. She speaks Cantonese (the family language), Mandarin, and French. Her enthusiasm and desire for new ideas and people led her on to the Ivy League.

The first year at Yale, where Nancy is majoring in molecular biology, proved even better than she expected. "I love this place. I was surprised by the amount of freedom. We have 'shopping period,' where you visit classes for two weeks before you sign up. I have a course in Mandarin that meets at 8:30 in the morning—we study the culture as well as speak the language. I can't wait to get there. And of course, talking with students, sitting up under a tree until three or four in the morning—those are the conversations I will always remember.

"My family has limited resources, but they gave me much more than material things. They taught me to work hard and take advantage of opportunity. What I've achieved reflects what my family, my school, and my community have given me. When I was scared, I asked for help, and it was always there. When you need help, ask."

Pamela O'Brien

The human spirit is more powerful than people realize.

Even as a little girl, Pamela O'Brien had a spirit that was stronger than she knew. It was strong enough to sustain her through what she defines as the ultimate abuse of a child: sexual abuse by a family member. And she believes that the same spirit enabled her family to survive what is surely one of life's most frightening and difficult situations.

"For me, the story starts with my parents' divorce. I was seven. Divorce was not as common then; there was more stigma. My father left my mother with five children and absolutely no support. The only way she could keep us all together was to move in with her parents. We had spent time with our grandparents in summers and had a close relationship with them, and we needed their help."

Pamela's mother took on two jobs, working from early morning until late into the night. She relied on her parents to care for the children, two boys and three younger girls. The grandmother was often away from home with civic activities and projects, so supervision of the children fell to their grandfather.

"Shortly after we moved in, my grandfather approached me. Before long, the sexual abuse began. Like all sexual predators, he found ways to manipulate me. He said that if I told what was happening, he would turn my family out and we would have no place to live. Because I had seen our house repossessed, this possibility was real to me. He also told me that because I was a child, no one would

believe me. And he said that if I refused, he would molest my younger sisters."

The abuse continued, and after a couple of years, Pamela was horrified to discover that her grandfather *was* molesting one of her younger sisters. As the girls became teenagers, the tension in the house increased. "My sister and I talked about it, we tried to resist, and we struggled over what to do. One morning, my sister began arguing with my grandmother and finally told her what was going on. I backed her up. We were terrified. Our horrible secret was out in the open.

"Our family was in shock and disbelief. My mother moved us out of the house and got some short-term counseling for us all. That began a discussion in the family, but it did not go far enough.

"I went on to high school and college with my sense of self-worth badly damaged. I felt that I carried a deep secret, like the proverbial scarlet letter. There were stages of bitterness, frustration, anger, guilt, blame for myself, blame for family members. As I grew older and learned more, I realized that sexual abuse is never the fault of the child. Only one person, the abuser, is to blame, and he carries all the blame."

Reflecting on her experience, Pamela points out that, at the time, there was little understanding about the impact of abuse on families; few people realized the crucial importance of talking about what happened. "There were years when no one in our family spoke about what had happened to us. It's natural to want to put it all behind you, but it doesn't just go away. I can see that each of us in the family is still in a different place in coming to terms with the effects of incest, especially as we start our own families. I was robbed of my childhood; all my security and all my innocence were taken away. But the day we moved out of that house, I stopped being my grandfather's victim, and now I know that as a family we are survivors, not victims."

Gradually, Pamela was able to let go of much of her anger. "In college I realized that being angry and hating one person so much was exhausting and futile; it took all my energy. As I let go of the anger, I began to learn more and

understand more. I have finally realized that this is not something you 'get over.' It's something you come to terms with. I thought I had dealt with it, but as I was preparing to be married, and especially when I was going to be a mother, I had another perspective."

Pamela's hope is that better family communication today can help prevent sexual abuse, especially if parents speak openly with children and pay attention to their concerns. She believes that honest conversations enable families like hers to lead healthy lives. "We need to increase awareness and compassion, both within the family and in public discussion. Families need to talk candidly, while accepting that people deal with trauma in different ways. Much more sexual abuse occurs than anyone wants to admit, and it happens to boys and girls, in every type of family. Tragically, it's usually someone the child knows and the family trusts. It's vital to talk about it and not internalize the feelings.

"Even as a child, I knew that I was a good person and that somehow I would survive; I was determined that this man would not destroy me. Our family was helped by friends, good people who were there for us. I was fortunate to have close friends and healthy relationships. These friends, including my husband, showed me that most people are good, and they helped me to

trust again and to believe in myself. I had to work hard, but I did regain a sense of confidence and my own value. Deep inside, I always knew that someday I would lead the life I wanted, and now as I see my daughter growing up in a safe and loving family, I know that my spirit got me through."

Joan Brock

I am happy, because I choose to be.

Choosing happiness is the Holy Grail of the positive thinking pundits, and most of us define it as impossible. But when Joan Brock stands on a stage and tells a thousand business executives that she has made this choice, they believe her.

She tells her story simply. "When I was thirty-two, I lost my sight in a matter of weeks. I will never again see my daughter's face. I can never get into my own car and drive off on a fall day, to see the leaves flying by." Sensing the audience's tension, she adds with a giggle, "But some days I think I'll just drive a block or so for old time's sake."

The audience laughs and relaxes. Joan may not be driving the car, but her destination is clear. After Joan recounts how she lost her sight to an early and inexplicable onset of macular degeneration and describes how she learned to live without sight, she reveals that just a few years after her vision loss her husband, Joe, died from a rare form of cancer. The audience is still. How can anyone present a story like this with such a glow?

"When I speak," Joan says, "my purpose is not to help the audience understand blindness. There is no way I can convey the finality of never seeing, just as there is no way I can truly convey the irreversibility of Joe's death. But everyone in life faces challenges and difficulties. I use my story to remind people that there

is a balance in life, and that finding the light side is a gift from God. Life is hard. It's how you deal with it that matters. And I have chosen to be happy. My story is terrible, but my life is absolutely wonderful."

Joan is not only happy, she is dazzling. A stunning blond, she has the smile and poise of a talk show host. She is a model of courage as well.

"One of my favorite descriptions of courage is grace under pressure. And this is particularly true for women. Most women have fourteen balls in the air—and 99 per cent of the time, they don't drop one!" Joan does her own juggling act: She presents her story to large and small groups, serves on boards and advisory groups, and is the national spokesperson for Prevent Blindness America. In addition, Joan manages most of her daily activities independently, aided by adaptive devices such as a talking computer and a braille watch. Joan is always busy, but mostly Joan is herself.

But Joan is no Pollyanna figure. "I'm not saying that because I have faith and choose happiness, life is easy. It's a continual job. There are really hard days; frustrating, terrible days. I struggle. But I was raised to deal with life as it comes, and taught that life goes on, grimly but triumphantly."

Joan believes her strength, faith, and capac-

ity to face a set of challenges that would overwhelm most people come from her parents. Joan's father was a minister; her mother was his strong, quiet partner. Growing up in Bakersfield, California, Joan lived in a parsonage next door to the church, and witnessed the darks and lights of life—birth, youth, marriage, illness, death—at firsthand.

"I saw things like this through my father's eyes. He lived his faith in a very practical way. I learned that bad things happen to good people, and that we don't understand why. I do not believe that God punishes people, just as I do not believe that God caused my blindness or Joe's death to make me an example. I believe that it's up to us to deal with loss, all kinds of loss, and that with faith, family, and friends, we can do this."

Her career as a motivational speaker grew from a friend's remark. "My daughter Joy and I had moved back to Bakersfield to be near family, and a teacher whom I had loved asked me to speak to a women's group at her church. I said of course I would do it for her, but asked why they would want to hear what happened to me. What she said changed my whole view of my experience. She said, 'I want them to hear you, because so many of them are so bitter over so much less.'"

Joan leavens her powerful story with humor.

One way she conveys the reality of her blindness, and her bubbly approach to it, is through stories of being a sightless mother. Joy was three when Joan lost her sight, and she became her mother's assistant. Joy accepted this new role in life, just as her mother dealt with her loss of sight. But it wasn't always easy.

"Once Joy went with me to shop for a new white blouse. I was determined to be independent, and while Joy was looking around for what we wanted, I bumped into a woman. I apologized and then asked if the woman could direct me to the white blouses. Joy grabbed my hand and whispered, in that teenaged tone of exasperation, 'Mother—stop it—that was a mannequin.' So I managed to embarrass my daughter just like all mothers."

Joy was given back her chance to be a child, and Joan's life was restored to fullness, when Joan married Jim Brock. Jim shares Joan's funny bone and zest for life. Once after grocery shopping, Joan opened a package of M&M's, pouring them into the candy bowl with no help. Only what Joan thought were M&M's were elbow macaroni. Jim said, "Let's leave them. People will just say, 'Oh, poor blind girl.' They'll probably go ahead and eat them."

Joan's life is full to the brim. Through her speaking and writing, she helps others to take a

more constructive approach to loss and difficulty. She travels, meets new people, and widens her world. But the core of her strength comes from her personal life. "Jim and I have a wonderful time together, and Joy is growing up into an amazing young woman. The world has opened up so much to me."

Paulette Braun

I decided I'd rather run off and join the circus—

so I did!

Dreaming you are in the circus is a beautiful fantasy—tights, lights, spangles, and the daring young man on the flying trapeze. Paulette Braun actually lived this fantasy—and toured the South Pacific with the Harlem Globetrotters. Later in her life she became a photographer whose images of dogs are widely reproduced in calendars, magazines, and books. Quite a life for a girl from Nebraska!

"I always wanted to do something a little different. I liked making my own decisions and going against the grain. I spoke my mind and stuck to my guns. My parents raised me to be independent, and to take care of myself. However," Paulette reflects with a laugh, "not long ago they asked if it wasn't time I got a real job. Like all parents, they still worry."

Even as a little girl, Paulette twirled the baton and loved to perform. When she was ten, she decided she was ready for the big time. "When the circus came to Omaha, I convinced them that I should lead the Grand Entry Parade around the arena, and I marched at the front of the Shrine Circus Band." Paulette continued to perform as she grew up. She finished college ready to teach elementary school, but she'd had a taste of show business and was drawn toward the bright lights.

The next step on the sawdust trail came when Paulette met a trapeze catcher. To follow the catcher *and* the circus, she developed her own act. "I had been in a lot of pageants and developed a fire baton act for the talent competition. So I upgraded my act and started working with agents to find bookings with shows, fairs, and other events. I needed publicity shots, and I worked with photographers as a model.

Even then, photography fascinated me, and I wanted to learn more."

One of the jobs Paulette got was a Christmastime appearance on Chicago's *Bozo the Clown* television program. Not long after the program, she got a call from the Harlem Globetrotters. They had seen the show and wanted her to open the half-time act for a coming tour.

"So I went off to the South Pacific with the Globetrotters. There was one other girl on the tour of about forty people. It was great. I worked with my fire batons at night, and had my days free in places like Australia, Hawaii, New Zealand, and the Philippines. I saw so many incredible places and did so many new things."

After the South Pacific tour, Paulette booked her act around the midwestern circuit, and soon teamed up with another performer to create a slack wire act. The pair traveled widely, including a three-month stint in Mexico City. "This was my favorite job, because most of the time all I had to do was be the 'Taa-Daa Girl' for our slack wire act. Being in the circus is great, but it's not as glamorous as you think. It's mostly hard work, loading and unloading, setting up, working in the rain. You drive between shows and sew your costumes in the truck. But now I had some extra time, so I started doing the publicity photos for the other acts. Because I knew what was coming, I could get the action on film."

Eventually Paulette found herself in Florida, working some small shows and doing occasional office work. She was learning more about photography, and put this interest together with another lifelong passion—dogs. "I had always loved dogs and had them as companions, even when I was traveling with the circus. A friend told me that a lot of people in Florida don't get out much, and she suggested I go to people's homes and photograph their dogs. I bought some used lights and camera equipment and tried it out. Going into homes was too difficult, but by then I was work-

ing with my own dogs more and I had a better idea. I set up a booth at an obedience show and that was great. Everyone wanted a really good picture of their dog. I started working bigger shows, and from there I began doing commercial photography. The American Kennel Club liked my work for their magazine, so I began to shoot slides in addition to the prints I did for people at the shows.

"Today I operate my own stock photo agency, with about 900,000 images on file." *Pets by Paulette* pictures are widely published. Paulette maintains an enormous stock of costumes and props, and her own dogs are trained models who wear costumes without complaint, hold a pose, and keep their ears up on command.

Paulette also breeds and shows dogs. "For my first show, I thought it was like show business, and I planned to wear a kimono and put little umbrellas on the dog's harness, because chows are Chinese dogs. Fortunately, a friend found out and suggested a skirt, blouse, and sensible shoes instead. I would never have lived that down. But I do miss the glitter." Paulette's smooth-coated chow, Dreamer, won six best in shows in one weekend, and she has raised a number of other champion dogs.

Reflecting on her unusual life, Paulette is thoughtful but certain. "I don't think I would change anything. I have a lot of energy, and I enjoy being active and accomplishing things. It's been hard work, and often financially difficult, but it's been a life that is full and free."

Tiffani Davis

Everyone said I was crazy, but I was determined.

I wanted to be a superstar.

Athletics and team competition are part of life for many young women today, but Tiffani Davis is at the leading edge of female sports. She plays professional football.

"Last summer I was working at the Rec Center with some friends and we were reading the paper. Right after the section on the NFL there was an article about the Tampa Bay Tempest—a women's pro football team! I got really excited, and I said to myself, I have a knack for sports. What if this makes it big, and I didn't try it?

"So I called the newspaper, and then I had to track down the writer, and then he had to find the person who gave him the story, but I kept calling. Then I found the Website and checked it every day. One day it said there was an open tryout, so I went out and I did pretty good in the trials. I made the team as a running back."

Lively, pretty, and slender, Tiffani is a woman with a straightforward philosophy that complements her talent. "If I believe I can do it, I try." Turned out she could do football just fine.

"I always loved football. Followed the games, understood it. But I only

played a little powder-puff in high school. Women's pro football uses the same rules as the NFL, except for no hitting below the waist. But who can say where you get hit? It can be pretty rough. Like in practice, we have a pretty cocky offense, and the defense will come and nail you. I get ready to fight if someone hits me after the whistle."

Tiffani had no problem mastering plays and producing on the field, but the new women's leagues were just organizing, and there were some disappointments. Her first team, the Tempest, traded her to a contending team with no notice. Tiffani went to practice twice with the new team, and then played in the conference championship. "We lost in overtime."

Then her luck changed. "A friend of mine bought a team in the Women's American Football League (WAFL). It's the Tampa Bay Force. We have real uniforms, real coaches, we get paid, and we get respect. Practice is four days a week." The league has a ten-game regular season, plus an exhibition season. "We get a pretty good crowd at home games, and a lot of people come out to watch us practice, because we do it in a public park. We played in a stadium that is the spring training facility for the Tampa Bay Devilrays.

"Because I'm a running back, everybody is always after me. When I run over people and keep going it feels so good. Nobody hurts until the next day, because you get pumped up and don't think about it. But the next morning, everybody aches.

"I love playing. There are about fifty women on the squad, all ages and from different backgrounds. The

youngest is eighteen, and she moved here from North Carolina just to play football. The women out there have that real love for the game. They try so hard. These are some of the best friends I have ever made. We take care of each other. We're all sisters."

Tiffani does not have to try quite as hard as some of her teammates. She played volleyball and basketball in high school, plus her favorite sport, track. "I'm a track fanatic; I eat, sleep, and dream track." She was a twelve-time All-American in junior college and on several championship indoor and outdoor track teams, and an All-American long jumper when she went to the University of Miami.

Her experience in school prepared her for achievement in areas beyond athletics. "It's good for kids to do sports in school. It makes them keep their grades up and teaches discipline. I recommend letting them do it. I'm not sure I would have done as well in school if I hadn't had sports to motivate me and to look forward to."

A woman with energy to burn, Tiffani has recently been a substitute teacher while finishing her degree in psychology. Although she substitutes in junior high and high school, she reports no problems with discipline. "I'm pretty tough, so they do what I tell them. I wasn't planning to be a teacher, but a lot of these kids really need some help. So I think I will teach for a few years." She is also raising her son, Deon Jackson Jr., now two. "Deon loves football—he was getting in a three-point stance before he could walk. He is always begging to play. His dad was a football player, so I guess it's in the genes."

Tiffany expects to be a full-time classroom teacher and possibly a coach, as well as a mom and a football player. Even if she has to put away her helmet for a few years while Deon is growing up, she says, "I'm nutty about playing football. I've enjoyed every minute of it. I wouldn't change it for the world."

Tori Norman

Sometimes when you can't find strength in yourself, you can look at somebody else and come up with a little more.

Until she was twenty-nine, Tori Norman led a lively and energetic life. Raising her son Daniel and working as a nurse in a cardiac intensive care unit, Tori loved outdoor activities such as biking and windsurfing. But in 1988, her future went from bright to dark when, while lifting a patient, she triggered a congenital back problem. Surgery to repair the disc injury left Tori with constant, debilitating pain and muscle spasms in her legs and back.

"I felt that my life was over, and I desperately wanted to not hurt any more. The doctor recommended another surgery, and after that one I spent four months in a Boston Overlap brace, which essentially held me immobile while the spinal fusion healed." When the brace came off, Tori could not bend or rotate her torso. "I wanted my old life back, but I was afraid it wasn't possible." A doctor described Tori as 55 percent disabled. "I told my surgeon this and he said, 'That sounds about right.' I burst into tears."

Through all the pain, Daniel stood by his mother. "Daniel was just eight years old, and before the second surgery he told me, 'Mom, I'm going to be really good this time, so you will get better.' He blamed himself. That's how children think." Daniel tried to care for Tori as she struggled to regain her mobility after

the last operation. "I remember once when he had spent the night with a friend, he called in the morning. This little voice said, 'Mom, are you ready for me to come home and put on your shoes and socks, so you can go for your walk?' I felt just terrible."

At her lowest point, Tori found herself slumped on the kitchen floor, unsure if she could go on. "I just didn't know if I could do this any longer. I was suicidal. Then Daniel's dog walked in the door, and I knew that I had to keep going for my son. This amazing child was always there for me.

"I'm a nurse, so I researched and found a rehab program in Sacramento modeled after the Texas Back Institute. This was about two years after the surgery, and at that point, on a good day, I could touch my knees. I had constant pain. The program was unorthodox, and included stretching and other activity most back patients were told to avoid. I switched ice packs all day long so I could stand the pain, but I figured it was worth it if this was the last chance to get my life back."

The four-month intensive program at the rehab center convinced Tori she could increase her mobility, and when it ended she began her own exercise program. "I wanted to go back to bedside nursing, and I wanted an active life. My first goal was just to walk with a normal gait. Then I decided to try riding a bike. Not like before, but a little. I found someone who adapted a bike for me so I could ride for a while without too much pain. And I worked on my attitude. I had to stop being angry that this happened to me, and just be thankful that I didn't hurt as much as I used to."

As Tori was improving, she saw a newspaper ad for rowing lessons. "I always wanted to learn to row, so I signed up for a three-week class. I had so much pain at first that I thought I couldn't do it, but I decided to stick with it." Tori had found her passion. Determined as always, she joined the River City Rowing Club and worked to gain

strength. Now she rows three or four days a week year-round. "I just get out there and do it. In May 2000, we rowed in a 10K race in Petaluma and we won. The rowers are an amazing group of people, and it's wonderful to be out on the water, especially in the early morning."

Rowing led Tori to true recovery. "Only in the past few years have I been really active again. Life is there to be enjoyed, if you can decide to not be miserable. I got stronger, and finally I reached a point where, although I have pain every day, I can adjust. For example, I went snowboarding not long ago, just on the beginner slope, and the next day I had pain, and people at work asked about my funny gait. But it was worth it."

Although Tori still thinks of her life as somewhat restricted, her activities would daunt most people. Recently Daniel left college to join the army, and has his heart set on being an Airborne Ranger. Tori remarked to a friend that she thought Daniel had enlisted "so he could jump out of airplanes." Her friend replied, "Tori, didn't Daniel jump out of an airplane for the first time with you?"

"It's true," says Tori, with an infectious laugh. "Daniel and I did a tandem jump for Mothers' Day a couple of years ago. I guess I can't complain."

Tori is back to her live-wire personality, full

of fun and eager for life. She has returned to nursing in a cardiology practice. "The forties are marvelous. I appreciate every day. When I worked in the intensive care unit I always wanted to know that I could make a difference in someone's life, and that's how I live—doing the most I can. For me, 'I can't' is not an option."

Marty Evans

There is enormous satisfaction to be derived from service.

Marty Evans served in the navy for almost thirty years, although she planned on only two. Seizing every opportunity to learn and lead, she championed the drive to base all military assignments on ability, not gender. Now in her second career, she is leading the Girls Scouts of the USA into a new era.

Marty was headed for graduate school, planning to study Asian history and politics, in the spring of 1968. On Easter weekend, she saw a newspaper photograph of a female naval officer and something clicked. "Over the weekend, I talked myself into enlisting, then out, then back in. On Monday, I called a recruiter and discovered that I could serve for just two years, travel, learn, and lead. I was tired of going to school and wanted a break. So I deferred graduate school for the time being.

"My first assignment was fascinating; I served in Washington, D.C., as an intelligence officer. I met great people. When my two years came to an end and I prepared to leave the navy, my boss's boss asked where I was going, and I told him I planned to go to graduate school and become a great Asian scholar. Within three days, the navy suggested I spend a couple of years in Japan at their expense." This pattern—great assignment followed by great assignment—kept Marty in the navy long enough to enrich her life, and to change the navy.

"After Japan, where I learned everything I could, including the language, I

was selected for a small navy program where I could go to graduate school, fully funded, so I did a master of arts in law and diplomacy at the Fletcher School."

Marty served at the White House during Watergate. She went to London to do policy planning, coordinating navy needs with NATO objectives. During her career, she was second in command at the San Diego boot camp, and commanded an engineering training center for fire fighting and damage control.

Marty advanced quickly in the navy. "After 1972, I never had a job that a woman had held before me, and I assumed women would follow, but generally, they did not." Marty was focused on the long term, and confident that as more women entered the navy and served well, their opportunities would increase.

That changed in 1986. "That's when I became militant. I was essentially an assistant dean of students at the U.S. Naval Academy, responsible for the military training of 720 midshipmen, and I saw how badly the young women were being treated. I spent about four months gathering data and developing a strategy, then I approached the leadership of the academy. I put it this way: If this is the training environment for our junior officers, and we are shaping their attitudes and values for the future, we

should make some significant changes."

Marty's action led to a major study comparing female and male midshipmen over ten years. Soon Marty was on a thirty-member panel looking at the entire service. That report, "Women in the Navy," called for opening Combat Logistics Support Force (CLSF) positions, such as supply ship assignments, to women.

In 1992, Marty Evans became an admiral. She was at the top of the navy structure. More women were enlisting, especially after the draft ended in 1972, but the environment was not changing fast enough. "I was called back to the Naval Academy to help. Then in the wake of the Tailhook scandal, I headed a task force. Our objective was to develop a strategy to change the culture and climate of the navy and marine corps to respect and value women. The most dramatic conclusion was that the law excluding women from combat must be revoked. This happened in the winter of 1992."

In summer of 1993, Marty Evans became head recruiter for the navy. She was the voice of the service, giving hundreds of talks and interviews a year. Is she satisfied with the progress? "I am grateful for how far we've come. The navy is now about 14 percent women, and women are proving themselves in every assignment. There are still barriers, and many of our best women leave after twenty years and forgo

future promotion. But the opportunity for women is much, much better."

By 1997, Marty was commanding the Naval Postgraduate School in Monterey, California, and the Girl Scouts of the USA was searching for a new national executive director. "I'd never looked for a job, thought it might be time, and agreed to an interview. During my years in the navy, I had developed strong feelings about the importance of guiding young people toward healthy development, and this job seemed perfect." Marty and her husband, a former navy pilot, packed up and moved to New York.

"When I took over the Girls Scouts, it was an underleveraged, underappreciated American icon. We had cutting-edge programs that no one knew about. My objective has been to expand our offerings so they are contemporary and convince the world that we are not old-fashioned." Girl Scouts are adding more math, science, and technology activities, offering career mentoring at all ages, and working to improve literacy. "One troop of nine-year-olds is building a giant dollhouse. They consulted women architects and engineers, learned to use power tools—and it's all for a homeless shelter."

GSUSA, already the largest and most eminent organization for girls in the world, has a million-member initiative. "We had a Girl Scout on a National Science Foundation expedition to the South Pole. I have Brownies e-mailing me as they master the computer. The organization is amazing, but more people need to know that what we are doing is what girls need today."

Girl Scouts of the USA is Marty's latest great assignment. Using her navy-honed skills of leadership and her commitment to young people, she is enriching and expanding another tradition. And if any young woman needs to know she can achieve, she can look to Marty.

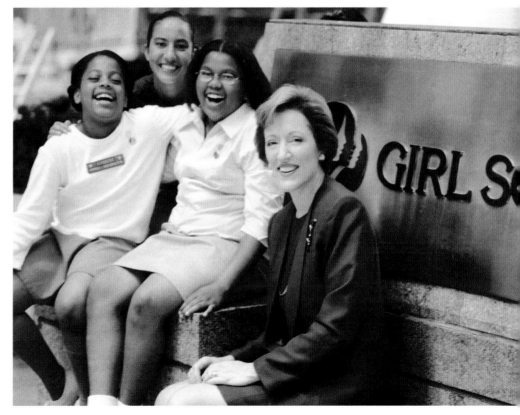

Elizabeth Eichelbaum

I'm getting ready for a party. It's small, just sixteen for dinner, mostly family. I rub, I scrub, I do everything. I don't wait around.

Elizabeth Eichelbaum, at age ninety the oldest person in the world to earn a Ph.D., has never waited around. The pace of her life is nonstop. She is an inspiration to everyone who knows her, and her story is one of determination, talent, and hard work.

Elizabeth and her sisters didn't arrive in America until she was eleven. Trapped in Russia during World War I after their mother emigrated, they ended up in an orphanage in Kiev. "It was an abandoned palace, but there was no food. When we got any food from the outside we tried to share it, because children all around us were so hungry they were crying." After the war, an American reporter came to the orphanage and wrote a story about the girls, including their

names. Through the story, their mother found them and sent for them to join her in New York. Elizabeth started school there, but had to stop after eighth grade to go to work. "My mother thought, like everybody then, girls just learn to read and write and then they get married. I always knew that someday I would go back to school. I wanted to learn, and for years I felt embarrassed because I didn't have an education."

But the education had to wait. Elizabeth and her husband bought and ran an all-night kosher-style delicatessen, The Bagel, in Detroit. "We had a choice: to buy a bakery or a restaurant. My husband was a baker, but I said a restaurant is better. You meet people and you don't stay up all night with flour in your lungs. So we bought the restaurant." In Detroit they raised four sons, including twins who became artists. Elizabeth herself loved to draw and paint. She took some courses and discovered that the twins didn't have all the family talent for art. Still, her desire for a formal education was strong.

"When I was sixty-five I told my sons, I'm going to register for high school. They said, 'Ma, you don't need to register, just take the test.' So I took a test, and I did so well they said, 'You should go to college.' I got an associate degree with a 4.0 average, and then I got a bachelor of fine arts from Wayne State when I was sixty-nine.

At eighty-one I completed the master of education and a degree in art therapy, both at Wayne State. Soon after, I received a specialist in education degree."

Then, in May 2000, Elizabeth received her Ph.D. from the University of Tennessee. Her thesis focused on art therapy and self-esteem in older adults. For many people, achieving a doctorate at an advanced age would be the culmination of a lifetime. They might consider sitting down for a while. But for Elizabeth, who was interviewed on *Good Morning America* and profiled in the *New York Times,* the degree was just one more milestone on an open road. She still has work to do. She gives talks and encourages activity for older people. She continues her work as an art therapist in retirement communities. She understands how to introduce the elderly to the therapeutic experience of art.

"My job is to make them know they are alive. They give up for various reasons—friends and relatives die, their health is not great, they just lose themselves. My job is to wake them up. I start with whatever they can do."

Elizabeth has encouraged many "hopeless" patients to become active. "I say to them, 'How do you know you don't know anything if you have never tried?' When they say, 'My hands hurt,' I say, 'You work with your hands, you forget your

pain. Then your mind works more and your hands hurt less.' And they do it."

Seeing Elizabeth arrive with art supplies must be a wake-up call in itself. A lovely and youthful-looking woman with boundless energy, Elizabeth is not deterred by the loss of sight from macular degeneration that has reduced her vision so that driving is impossible, reading is almost gone, and many tasks are difficult. "It's frustrating but there's nothing I can do about it. I have helpers that read to me and help me when I need it. I am still independent."

How does a painter cope with fading eyesight? "I've been painting a lot lately, and it looks different. People tell me it's freer. I give a lot away now. Many great painters lost some sight at the end of their lives. A lot of artists can't break loose, but when you can't see so good you loosen up. When I'm painting there are no dull moments."

According to family lore, Elizabeth has always been guided by her own credo, the very one she repeated to her sons whenever they complained that something was too hard, or that something was beyond them. Their mother always said, "Don't ever tell me you can't do anything. You may not do it as good as others and you may do it better. But don't tell me you can't do it."

Neale Godfrey

It never dawned on me there were limits.

Neale Godfrey never got the message that some things are hard to learn or that women are expected to defer to others. She wore cowboy outfits to kindergarten when girls were required to wear dresses. She was the only person in Vietnam on

a tourist visa during the war. She made herself into a top-notch banker, then launched a whole new venture to educate kids about money. Her house is painted with electric colors and one room is a caboose.

"If you want to you can, and it's not a dress rehearsal. I always knew that I could learn anything. As a kid I always had an angle. At age ten I charged kids twenty-five cents for a tour of the sewers, and they kept coming back. I sold newspapers. My father left us destitute, so my sisters and I each worked our way through college in three years with honors. It costs less if you go fast."

This woman is not a time waster. Warm and humorous and full of fun, Neale Godfrey powers through life with a commitment to accomplish, to give back, and to enjoy life.

Neale's early goal was to become a diplomat. But after graduation she married a law student and had to find work. "There weren't many jobs for someone with a B.A. in international affairs, and most jobs open to women were typing and clerical work. I figured I could adapt my negotiating skills to business, so in 1972 I got an entry-level job at Chase Manhattan Bank. I knew that if I got my foot in the door I would have no trouble excelling." Within six months she helped design and implement a major loan package for Argen-

tina. In 1974, Chase sent her to its most competitive training course and she graduated first in her class (half the students dropped out). She rose to the top at Chase, then was asked to become president of the First Women's Bank. Neale took First Women's from $45 million to $400 million in three years. As her career soared, Neale gave birth to her daughter, Kyle, and then her son, Rhett.

At First Women's, Neale observed her customers and their needs closely so she could tailor and improve banking services. She discovered some surprising things. "Eighty-five percent of women do financial planning only in crisis. This is not okay. Women are not taught about money, and consequently they don't have the skills to teach their children. I wanted to do something to change this." Even Neale, with all her connections and resources, could not find an agent or a company who wanted to undertake educating kids about money. So she did it by herself.

"By then I was divorced and supporting the family, so I talked with the kids and told them that I wanted to teach kids about money, and asked if they were willing to make some sacrifices. Kyle was about five, and she said, 'Mommy, children need books to teach them, so you have to do it.' The kids recall this as the 'macaroni' time, because we had to change the way we lived."

While still at First Women's, Neale opened

the First Children's Bank, located inside F.A.O. Schwarz, the famous Fifth Avenue toy store in New York City. Children six and older could open and operate accounts, with their parents' participation.

The media loved First Children's. Neale became a money guru for television talk shows (she's been on Oprah's show thirteen times), and from this base she developed her current venture, the Children's Financial Network. CFN develops and promotes teaching materials about money, to be used in the schools. Neale finds partners to help her in the effort. For example, John Nuveen Company (JNC) paid for curriculum materials for grades K–6 in 750 Chicago public schools.

Neale has raised Kyle and Rhett with a system that she encourages all parents to adopt. The children divide their allowance, which they receive for services rendered, as well as any money they earn independently. Ten percent goes to charity, the remaining 90 percent is divided into thirds. One-third is "quick-cash," for short-term treats and instant gratification; one-third is "medium-term savings," for items like fancy jeans or sneakers; and one-third is "long-term savings," for stocks, bonds, and mutual funds. "By age twelve, kids should be on a budget and be managing a joint checking account with their parents. If you don't get these lessons across early, kids don't know where money comes from, don't understand how to use it, and

don't develop priorities and values around spending." Neale also taught Kyle and Rhett about money and choices by having them develop proposals for trips and vacations.

The author of thirteen books on money, life skills, and values, Neale writes numerous articles for both kids and parents. "Money can be a healthy part of your life, providing you with the things you need and enabling you to help the less fortunate, or it can be devastating and tear your life apart. I want people to know how to design the lives they want, create their visions, and achieve them."

A conversation with Neale suggests that there are likely to be many more adventures and accomplishments after the Children's Financial Network. One of Neale's mottos is, "You need to look in the mirror and not have regrets about what you didn't do."

Wilma Huggett

We need to make things right.

Growing up on a 120-square-mile ranch in Arizona, Wilma Huggett learned to ride and rope and shoot, speak her mind, rely on herself, and love the earth. The 3C Ranch in the 1940s was a place of cattle drives, hired hands, and generosity. "Christmas lasted a month. We butchered two steers and five pigs and distributed food in the town. My father brought home a truckload of nuts, oranges, apples, candy, Prince Albert tobacco, clothing, whiskey, and toys. Everyone at the ranch, and their families, got what they needed. One year I chose an eighteen-foot spruce, and we had to cut off nine feet to get it in the house." Wilma and her mother, Elna Huggett, ran the 3C themselves after her father's death, an uncommon choice for two women in those days.

Today Wilma lives on eighteen acres. She is still self-reliant, raising vegetables and pumping water with a windmill. Her home, modeled on a Navaho hogan, is a round building thirty feet across, flooded with sunlight. She manages just fine about forty miles from Tucson. "This is the life I know, and it's good. I never thought of anything but ranching." At one time, Wilma was the third leading breeder of quarter horses in Arizona, and raised longhorns as well. Her stories, especially about her Arizona childhood, are famous. She's also well known as a rattlesnake "spanker."

"One came onto the property and my Buddhist friend asked him politely to leave. I knew he wouldn't go far, so I caught him later and banged him against the wall to knock out his fangs. They'll grow back. But another one, the kind we call coon-tailed, came too close to my porch. So I had to shoot it."

Completely at ease with wildlife and open places, Wilma is worried about the future. "I have a strong intuition for what is out of sorts, and these days I see a lot of things that are not good for the earth, caused by people. We need to do more to make things right." Wilma has deeded 215 acres to create a wildlife easement.

Wilma is also making things right by joining with women from around the world in the Council of Grandmothers. "The council is based on a Hopi teaching, 'When the grandmothers speak, the world will heal.' Every year more women join us, and our circle grows. The outer circle learns from the Elders, who are the inner circle, and we all learn from the Native American tradition." Next year, Wilma will herself become an Elder of the council. The values she learned at the 3C Ranch will pass on to future generations, helping to heal the earth.

Deidre Scherer

If you look at death, you see your life more clearly.

To protect their vision and their purpose, artists have traditionally given up comfort, financial security, and seductive compromises. To honor and develop their gifts, they find ways to survive at the margins of society. They keep making art. Deidre Scherer is an artist.

Over the past few years Deidre's current work—images of the elderly and the dying rendered in fabric—has become well known. *Laughing Rose,* a Scherer portrait that is the cover art for *When I Am an Old Woman I Shall Wear Purple,* is instantly recognizable: The book sold a million and a half copies. Success has allowed Deidre to work full-time as a studio artist. A visitor to her Vermont workplace would guess that this tall, calm woman, who moves with a fluid quickness, is a homegrown New Englander. The truth is that she arrived here a wanderer.

"I was always an artist. I drew and drew. I didn't speak until quite late, and I think it was because images came before words. After going to the Rhode Island School of Design (RISD), I began to roam the country, working here and there as I could, going into and out of relationships and marriages. It was the sixties. I lived in the Southwest for a while with a plan to teach on a reservation. In Colorado I had a child and planted a tree. I kept on moving. But I always knew that I had to be an artist, and that meant I had to protect my body, develop my craft, and not linger at forks in the road."

The forks included a small card company, stints of public assistance, failed entrepreneurial efforts complete with business plans, and teaching. "I knew that I could be a fine teacher, and that it would be a joy. But I also could see that it took all my energy, and there would be nothing left for my art. So I chose to stop teaching. Maybe later in my life. The failures in business taught me a lot. Failure is terrible, but it's worth more than a college education."

Deidre's three children, Gianna, Corina, and Sarenna, needed food, shelter, and love. Only love was available in abundance. After a long trip around the country to find a place where she could take root and work, Deidre settled herself and the girls in Vermont. It was 1975. "I liked the sense of place. It felt like a haven, and the winter brought a nice isolation that encourages work. I only knew one person and we were tenting with winter coming on, but I decided to stay. We moved into an attic, the attic of the house I now own, and I used an axe and wedge to cut wood for the stove. I was on and off public assistance. We lived on very little. But even in that attic I divided the space and set up a corner for my art."

A project for Gianna led to Deidre's shift from oils to fabric. "I decided to make a cloth book for Gianna, about patchwork characters. I'd never done sewing before and I was clumsy, but I stuck with it and as I worked I saw how flexible and expressive fabric can be. *The Beast at the Bed's End* took me six years to complete. By the time I finished it, I knew that I was going to be painting with scissors and fabric from then on."

In Vermont, Deidre met and married her true companion and partner. "I asked Steve if he would support me for three years of work, because I thought I could establish myself and make it in that much time. He said he would. I made serious boundaries for work, and took the whole attic for my studio. I showed my art everywhere I could, contacted dealers, went to fairs, and talked to people. I got on with it." In 1998, the Baltimore Museum of Art presented her in a solo exhibition, *The Threaded Image.* On a hot Sunday in May, three hundred people came to the museum to hear her speak.

"I came upon my subject matter by accident. I wanted to show more depth in faces and characters, and I had always liked older people and had older mentors. In 1981, I asked the activities director of a nursing home if I could come in and draw. When I went in I was completely captivated by the beauty. My blindness was that I had never looked. And if I didn't look, perhaps the whole culture was not looking at the importance of this time in life. I drew and drew, and translated these images into fabric.

"The faces were fascinating, so beautiful and distinguished. I could see that, as a whole society, we have no vision of old age after a full life. We don't want to deal with the reality of our own mortality, and all that it implies about our fre-

netic pace. We prefer not to check in, but if you look at death, you see your life more clearly."

She continues to portray the elderly and the sick, and most recently, the dying. An exhibit funded by the Open Society Institute, *Surrounded by Friends and Family,* is touring the country. "There is perspective and great wisdom that comes with age. I want that, and I want to show that—the dignity and beauty of these faces and these hands."

Deidre Scherer is changing the image of aging for our culture. In doing so, she joins the company of great artists whose eyes and hands give us new vision.

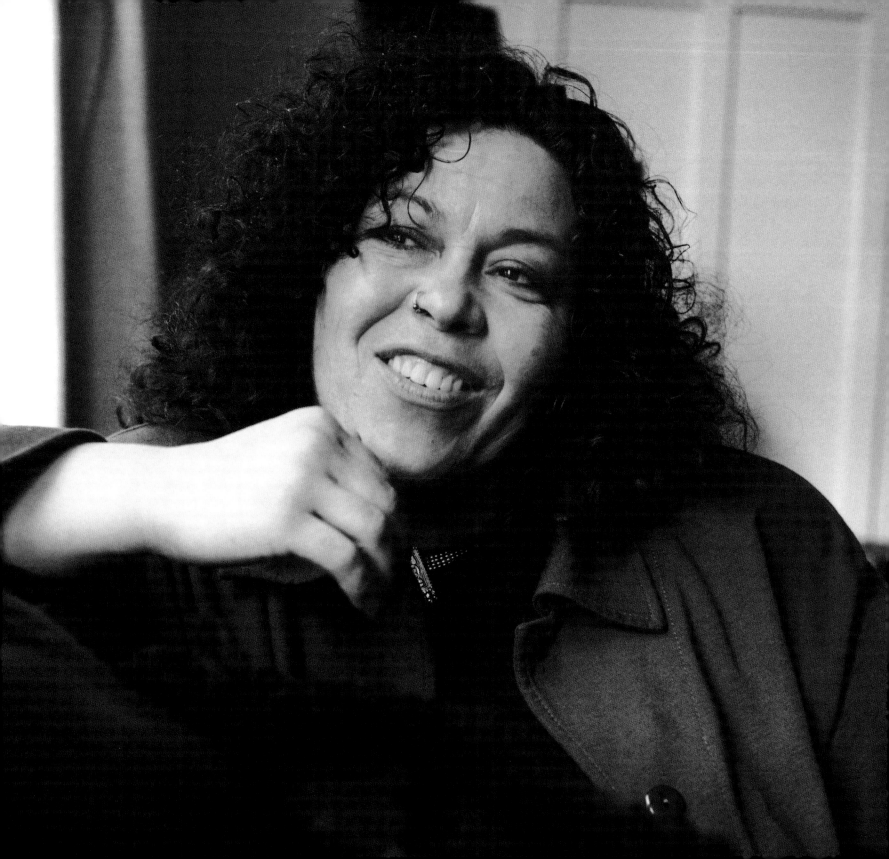

Sinthea Brown

When the chin comes off the chest, the back straightens up and the smiles come voluntarily, that's the moment I work for.

Describing her clients at Seattle's Partnership with Adults for Community Enhancement (PACE), Sinthea Brown conveys a rare grasp of their troubled lives and a respect for the struggle of people living on the street. Sinthea knows this road well; she has walked it herself.

"I say to my clients that they have veered off the path they are meant for, and I am in their path because I can help. And I know that they can change, because I did. After being homeless, a single parent, and a crack addict, I didn't think I could aspire to anything better. But here I am."

The difficult walk did not break her spirit. Sparkly eyed and bubbly, Sinthea brings style and sauciness to the PACE office, and competence. Recently married, Sinthea looks ahead to a career in social work and a happy home. Her perspective is surprising, considering her past.

"My family was not stable. There were a lot of problems and my dad disappeared from my life early. There were too many changes. I lost my place in the family structure, and left home. A lot was going down on the Seattle streets then. Kids were panhandling, going to clubs until early morning, shoplifting. I was arrested as a runaway, went home, got thrown out of the house again, and lived in

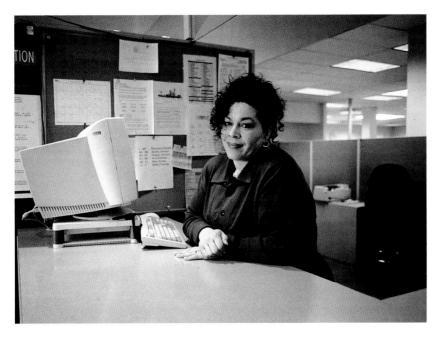

a vacant building. When I was six months pregnant I moved back home, but I was still connected to the stream of kids on the street. I knew the system.

"Having the baby was the best thing that ever happened to me. I was only sixteen, but I loved Joseph and I wanted things to be better for him. I got my GED through a youth training program, and worked on and off, but there were a lot of problems and conflicts. When I was eighteen I got married. He seemed like a good person, but the cycle of abuse started again. His dad had been abusive to his mom, so that's what he knew. I stayed married for eleven years. I believed there was nowhere to go. I had two more sons and no

hope. So I started using cocaine, because cocaine makes you mellow. In fact, it became my best friend.

"Things were really bad. One day I was shooting up and I saw myself in the mirror, and I thought about my children, and I said, 'I have to stop.' I was clean for three months before I started treatment." Sinthea remained off drugs, but the marriage was still rocky and, as she says, "The people I hung around with got worse and worse." The kids were growing up and Sinthea still had no clear future. Finally, in 1992, she got a divorce.

Sinthea had not given up, but she could not see her way. In 1995, she spent some months in Georgia, and that time made a difference. "I was living in a pretty townhouse with a new friend, I had my own room and my own bathroom. The children were in Seattle. I had never had this much space, or such a nice place to live. I had time to be quiet and think. I worked as a bartender and saw what women did for men when they had a few drinks. This helped me to stop drinking. I started looking ahead to the rest of my life."

She returned to Seattle, and in the fall of 1997 she enrolled in a career services program of Seattle Goodwill Industries. If she could make it through the course, she would learn computer,

office, and case management skills through on-the-job training and classroom instruction. Each morning and evening she commuted an hour by bus. She had to apply for food stamps, and this was discouraging, but she hung on. Sinthea completed the training and knew that her life was fundamentally changed. "I received so much more than training from Goodwill. I gained the confidence to push for something better. I do not have a better job from this training—I have a career."

Another life change came along in 1997. Before going to Georgia she met a cute guy in a supermarket who asked her to call him. She told him she was going to Georgia, and threw away his phone number. Five months later she was in Seattle and going home on the bus, when she noticed a man flirting with her. As she got up to leave, he said, "How was Georgia?" It was the man from the supermarket, John Brown. Soon they moved in together and in the summer of 2001 they were married in their church, Rose Hill Baptist. "John helped me renew my faith and commitment. I was able to see the Lord through him, and I had missed having a relationship with God. John loves the person I am.

"My life is together now, so I can be there for somebody else." Sinthea's clients at PACE come to her for financial advice and assistance, as they work toward finding jobs and staying clean.

"These people are so vulnerable, especially the women. They want to get off the street. Some will use the services, and some won't. A lot of people wrote me off, too, so I don't give up."

Sinthea delights in being a loving grandmother to Joseph's new baby. She is studying for a degree in social work, so she can continue to advance her career. She and John are building a life together. Sinthea puts it this way: "I work now for myself and for others, and I live by something I learned from the people who encouraged me at Goodwill: 'If you can see it, you can achieve it.'"

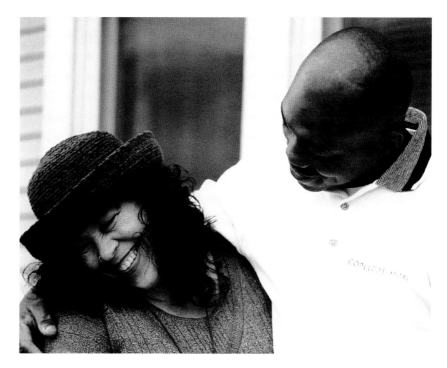

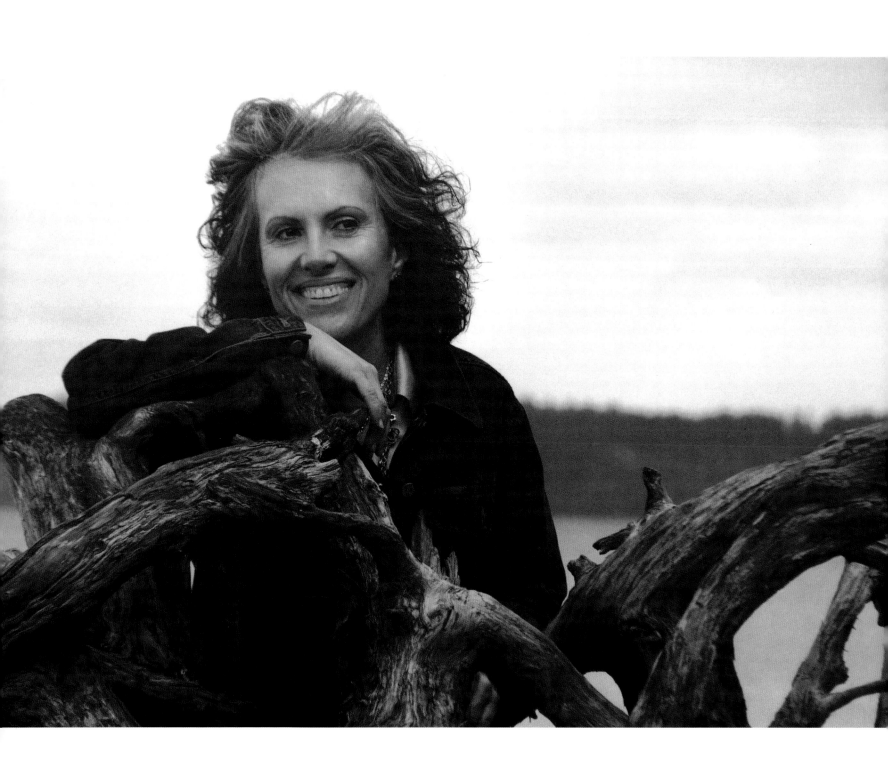

Danica Anderson

I come to bear witness. They sit with their pain and horror. I sit with my fear.

As a child growing up in the Bosnian Serb enclave in Chicago, Danica Anderson could see the unseen. She could interpret dreams, she could see the future, she could read people's emotions and desires. She had the kind of insight that unnerves adults. And she wanted to know where all the violence came from.

"I thought that the way my family lived, with so much abuse of women and children, was normal. My father and my mother both beat me, and I thought all little girls were treated brutally. The men held all the power, and the women reflected it. When I went to school I realized that we were different. I remember looking at my parents and knowing they were very sick."

Danica's parents had fled Bosnia to escape genocide and World War II, but they brought the old ways with them. To escape, Danica left home at eighteen and married at twenty. Driven by dreams and her sensitivity to messages and signals she did not yet understand, Danica moved into the realm of female spirituality and women's studies, eventually becoming a forensic psychotherapist, board certified as an expert in trauma. She moved west with her husband and found a place on Puget Sound in Washington State to raise a son and daughter.

As she worked with feminine archetypes and symbols, she discovered a kinship

with earlier women social anthropologists and scholars who had unearthed the long history of goddess influence around the world. Like Danica, most of these women, although they made enormous contributions to research, had been disregarded by their male peers. Danica realized that connecting feminine wisdom, first-person story, and mythology was her life work. What she did not realize was that her Bosnian childhood carried the seeds of her future.

"I went to Bosnia in March 1999, ten days before the NATO bombing. Medex Mine Awareness had asked me to come to Bosnia and help teach children how to survive in a place with three-million-plus land mines. I flew into the Sarajevo airport and went to work with women and children who were severely traumatized by the war, ethnic cleansing, and everything that went with it. I wanted to find a way to avoid more trauma; there had been so much.

"Once I was on the ground, everything from my childhood came back, the beatings and the violence, and I understood the reason for my earlier experience—it prepared me for this moment. Because I knew the language and the culture, I could connect with the women, and I began working with women in groups. Reading coffee cups is an ancient Bosnian tradition, and a very early psychological route to people's inner selves. It is a way women can tell their first-person story and not be shamed. We

sat in circles and read coffee cups. I looked into the coffee grounds and divined what the women had suffered. The women became more open, more able to confront what they had been through.

"Because men are so dominant in Bosnian Serb culture, the women have no tradition of supporting one another or intervening to stop violence. If they hear screams from the house next door, they might say, 'That woman should work harder to please her husband.' But when they sit together and share their stories, they touch their own personal storehouse of riches."

From these experiences, Danica began a new work and built upon a familiar symbol—the kolo. "Kolo is the Serbian word for circle, and it also means 'to dance.' As we sat together in the circle, the women learned to heal themselves and each other through story. As we danced we re-created ancient patterns of spirals and labyrinths, the paths of life. After dancing once in Novi Travnik, one woman asked to dance again, changing her steps to dance a new path for her life. These women, with all their trauma, know more than you and I. Anyone who listens deeply will be elementally changed through the Bosnian sisters' stories. This is feminine metaphysics, and this is what will enable us to heal a world of violence, if we bear witness to each other. The hardest thing is to bear witness, because we are so uncomfortable, and we want to

rush in and say everything will be okay. It is not okay. We have to sit with this, and it is horrifying." Danica found she had to sit with her own fears, her memories, and everything painful in her own life. The brutality of the Bosnian experience reawakened everything she had endured.

In addition to her work in Bosnia and a clinical practice at home, Danica travels the world doing workshops on feminine wisdom and archetypes. From her commitment to healing in Bosnia has come her Kolo Foundation. Each year she leads a work-study trip, bringing desperately needed dollars to the local women, who host the conferences and provide lodging and food. "As the circle grows, healing and feminine wisdom flow in all directions. The women become empowered to care for one another, to earn money, to begin to make a new society. They don't need me, they just need a way to find each other." She is also part of a movement working to establish domestic violence laws in Bosnia.

A striking woman with a vibrant face and magnetic presence, Danica moves with grace between a home filled with nurturing images of the feminine and the devastated towns of Bosnia. Through all her work, she carries a spirit of humility. "I often wondered why there was so much violence in my clinical work and my background, and now I know I was being prepared for this work. We are all women and spirits on the same journey."

Nancy Schafer

Ed was running third in a field of three when I agreed to date him. Nine days after we were engaged he was elected governor. I waited eight years for a honeymoon.

Nancy and Ed Schafer served as governor and first lady of North Dakota from 1992 through 2000. Handsome and eloquent, the couple were a media delight and an enormous success with North Dakota voters and citizens. Nancy's ease of

communication and her passion for health care and other issues are those of a woman who has been a public figure all her life. But Nancy's background was quite different. And although being an instant first lady was an enormous challenge, she had already been through a "world turned upside down" experience that tested her mightily.

"I grew up on a farm and ranch in Montana, where we didn't even have indoor plumbing until I was nine. I loved to drive the grain trucks, help with the harvest, and work the cattle. I went off to Concordia, a Lutheran college in Moorhead, Minnesota, and on the third night I met my true love, Morrie Jones. We married and had two children, and lived happily ever after until 1987, when Kari was seven and Eric was nine. Morrie was diagnosed with a rare thyroid cancer and died two and a half years later. And three months after that, Kari was operated on for the same cancer."

Nancy recounts this part of her life with the strength of a woman who has gone toe-to-toe with tragedy and come away the victor. "My husband had been treated at the Mayo Clinic, so I knew that the best diagnosticians were there. When Kari showed some unusual test results I insisted we return to Mayo. Kari begged me not to take her back there. She said, 'That's where Daddy died.' It was so hard for both of us. The surgeons removed her thyroid and treated the cancer, and when the day after her surgery they let me take her to lunch at Wendy's in her bathrobe, I felt certain she would be fine."

Nancy's Christian faith had been a constant in her life, but it had not been challenged until cancer appeared. "Suddenly my faith became personal. What had been head knowledge became heart knowledge. I had unfailing prayer support and help from my whole community, and a pastor friend basically got us through this. Once I knew Kari was fine and I began to look ahead, he told me that I had a special responsibility. I had no idea what that meant, but soon people began asking me to tell the story of my faith journey, as well as discuss cancer prevention and screening. I agreed to do this because so many people had helped us, and I wanted to give back. I think of this period as an extremely good education with a very high tuition. I wanted to graduate with flying colors."

Nancy had resolve to begin a new life, but she needed to find a job. She became development director and then executive director of the Fargo/Moorhead Symphony, and at a symphony gala she was introduced to Ed Schafer. Ed was a successful businessman who had decided to run for governor. "We dated during the campaign, and everyone assured me he didn't have a chance.

When Ed won the election I thought, 'What have I done?' He was sworn in on December 15 and we were married on December 17." Now the world was turning upside down again.

"Even if you are heavily involved in the political arena, there is no real preparation for being a first lady. Politics was new for all of us, and in North Dakota the legislature goes into session right after the election, so there was no time to plan. I decided that I would have to draw on my experience. I figured that if I could go through all we had gone through, and be a good single parent and work and run a home, I could be a first lady."

Nancy was an absolute smash at her new job. She relished the challenge and the opportunity. Traveling the state, she put extra emphasis on women's health issues, establishing a special focus on screening for breast and cervical cancer. She worked hard on children's health and safety issues, and for support of the arts. Surprisingly, Nancy concludes that working together as partners, even under such pressure, was a good foundation for marriage. "A key to successful marriage is to look not only inward and upward, but outward in the same direction. We have a shared passion, to make the world and the state a better place."

As a couple and as leaders, Nancy and Ed were successful. After eight years, they prayed hard about the future and decided not to run again, although Ed was a shoo-in for reelection. "He had vowed not to become a professional politician. Things were going very well in North Dakota, and we could see that we could accomplish more, but no one is indispensable. Change can be healthy, and we missed having time for ourselves and our family. It was difficult, but right."

Ed and Nancy declared a six-month moratorium to figure out their next steps. Both have been asked to run for other offices, but for now the future is simple. They are preparing for Kari's wedding, and "camping out" with a few belongings in Fargo for a while. "I don't need much to be happy. I'm catching up on things I haven't done for years, like doing my own grocery shopping. It's going to be fine, and it's going to be fun."

Nancy is certain that her accomplishments are the result of faith. Each day, she continues to use a prayer given her by her pastor in that difficult time, a prayer that reminds her that all of life is a gift from God. "Thank you, Lord, for all that you have given me, for all that you have taken away, and for all that I have left."

Bobbie Kinkead

After I saw her I could hear the insects and the tiny animals,

I could smell the dry grasses and see the stars. From then on I knew

I was not alone, and everything would be all right.

Bobbie Kinkead had a magical experience as a little girl—one that shaped her life and opened her to the deep value of all experience, the power of nature, the energy that humans, animals, and plants exchange, and a way of being in the world that is both accepting and powerful. Silver-gray hair and twinkling eyes announce a woman who is joyful, grounded, and fully alive.

When Bobbie was a child in Colorado Springs, that city was "a cross between mining and farming. As it got dark, the neighborhood kids would all run across a big field filled with high grasses. We knew a bad spirit lived there. We ran screaming and scared—when you are scared you can only hear thunder."

One summer night Bobbie fell down as she ran. The other children kept running and she was alone, with skinned knees. She beat the earth and screamed in terror. "Dust rose up all around. I knew the bad thing would get me." Then, she became still and something happened. "I looked up, and there was this lovely woman looking at me. I felt protected, and everything changed. She told me that there is light

here, not just darkness. From then on I had confidence that life is good."

Bobbie thinks of the presence as "the field spirit," and believes that she saw the spirit of nature, or "whatever it is that protects women." Bobbie never saw the spirit again, but senses the comforting presence.

One result of seeing the spirit was to root Bobbie deeply in her childhood, enabling her to retain a child's openness and expectation of life. "I function more at a child's level than most people. I sense things in trees and animals, I connect with babies, I feel vibrations around me and respond."

Bobbie believes many people have experiences like hers, but few accept the lesson. "We need to pay attention to our physical experiences. Live them fully. There are connections in life we do not understand, and they are good. Sometimes you have to fall down and skin your knees, and some dust has to come up around you, before you can be quiet and see the stars."

Deborah Lans

To a kid, the idea that someone has chosen to mentor them, to be in their lives, is amazingly powerful.

In June of 2000, Debbie Lans changed her life. She left a successful corporate law practice to lead Mentoring USA, one of the largest mentoring programs in New York. "Of course it was a big leap. I went from doing something with ease to being in a world that I didn't know, and I had to learn a lot. But I did it with enthusiasm, and I love what I do now. As a lawyer I understand what happens to a kid when no one intervenes when they need help."

Debbie has long had an interest in children, and a willingness to pitch in when something needs to be done. After law school she planned to work in the Juvenile Rights Division of the New York Public Defender system, but there were delays. "So after a couple of days I called my father's law firm and said, 'Can't I do something?'" She stayed seven years.

Then Debbie and some friends started their own general practice corporate law firm, and she found a way to practice law and serve kids simultaneously. "I realized that the firm's pro bono work was almost all connected to bar association or legal issues. Personally and organizationally, I wanted to see us doing something that had a different kind of impact. I called a group that ran mock trial

Mentoring USA

one to one
mentoring
impact for at
risk youth

programs for young people and asked for advice. I wanted to work with younger kids, because by the time they are in high school, it's too late to have much impact.

"The place I called said that a junior high school had been pestering them for two years, wanting to work with a law firm. The school had a law and ethics program and they needed help." Debbie contacted the school and found just what she was looking for. "There were two great teachers teaching law and ethics to sixty eighth-graders and sixty ninth-graders. The school is on the Lower East Side, most of the kids are relatively poor, and many are Hispanic. The teachers were talking about what is moral, what is ethical, using stories from the newspaper and formal debating tactics as well. It was perfect."

Debbie and a number of people from her firm developed a program with Corlears Junior High. The activities

varied, but every year the kids came to the firm and met the entire staff, so the kids could see that a lot of different skills are needed in a firm. "One of the most meaningful things was that we employed some of the kids in the summer and part-time through the year as they got older. When you work with kids every day you can have a tremendous impact on them.

"I saw how much sustained contact helped the kids. One day we had a hurricane, and when I got to the office, one of the kids had come in and was running the switchboard. She told me she knew most of our staff wouldn't be able to make it in, and that we would need help." The power of connection made Debbie think about doing more mentoring.

"After I'd been working with the kids for a while I heard about an opening for executive director here at Mentoring USA. I just came over for a talk, but after the interview was over, I found my self saying, 'This may be crazy but I'm doing it.'"

Leaving the law practice was personally difficult, because her friendships there were long-standing. And Debbie knew she was giving up some valuable things. "I had recognition, a client base, I had a place in every sense of the word. Starting a new venture later in life is risky. But I really wanted to do this, and it was time for me to learn something new and challenging." The challenge was real, because before Debbie arrived most of the staff turned over. "That was okay because it allowed me to hire some terrific people, but we were all new and there were times when I

thought to myself, What have I done? At first I was clueless when someone asked me a question. My experience didn't help me much here, the automatic pilot did not kick in. But we all learned together."

Debbie's program matches mentors from companies and organizations one-on-one with preadolescent children. Mentors commit to meet with the child at least four hours a month, for at least a year, in a school or community setting, with supervision and support. In 2000–2001, MUSA mentored about nine hundred young people at more than sixty locations in New York City, typically working with between fifteen and fifty children at a site. "You quickly see that the mentors get as much from this as the kids. You might have an executive, a secretary, and a bookkeeper from a company working together. It breaks down a lot of barriers."

But the reason for all this effort is the kids. "The kids are so excited when they first meet their mentors and understand that this is a person coming week after week just for them. Kids are too isolated, and this is getting worse as more mothers are forced to work. Mentors really stick with the kids, and they become their role models and advocates, because the mentors know how to negotiate the system.

"We know that kids who succeed despite personal and economic obstacles usually have a caring, competent adult who believes in them. We work to make this connection for kids before it is too late. I love coming to work every day, because I know what we are doing for so many kids."

Kalister Green-Byrd

You might fall down, but you don't have to lie there.

Sometimes one person with commitment can transform a community. Kalister Green-Byrd settled in Haverhill, Massachusetts, in the early 1960s, and has since become a local legend. No matter what blows life dealt her, she kept getting up and moving, confronting anyone and anything that stood between her family and the life they deserved. As she extended her caring to others, she made Haverhill a better place.

"You have to believe that God is the ultimate justice. You treat people the way you want to be treated, not how they treat you. Do what is right, and right will follow you. These are the lessons I learned as a child in Alabama, and they are my foundation. My course in life has been to do better, improve, and help others."

As a little girl in Alabama, she learned these lessons, but it was hard to follow them in the face of

segregation and racism. "My father used to say to us, 'There are some good white people,' and we would all laugh. Today I say to my children, 'There are many good people.' There is good in everyone."

Kalister, usually called Kay, always had a dream of a better life, a life that included an education and some of life's grace notes, like travel and beauty. When she moved to Haverhill, separated from her husband and with seven children to raise, the grace notes were a long way off, and she faced a basic problem—housing. Kay chose Haverhill because it was a manageable size and emphasized family and community. There were only a few black families, and almost no decent housing for large, low-income families. When she lost her home to urban renewal, she was determined not to leave.

"I became very strong. Here I was, this little black girl from the red hills of Alabama, but somebody had told me I had rights and there were laws that supported me, and I hung onto that." Kay went to the city council and the mayor and demanded decent, safe, and sanitary housing. "I said I would take nothing less. The NAACP and the church supported me and eventually the local housing authority provided a place. I vowed to make Haverhill a place where people had basic necessities."

Kay had a decent place to live and was becoming an activist in her community. She supported her family for years by working as a waitress. As the children grew older, Kay slowly began to add to her education. "I had learned that the more knowledge you have, the more power you have." It took her seven years to obtain her first degree; she graduated from Salem State the same year that two of her children graduated from other colleges. "By then I had had it up to my neck with studying and was going to stop going to school, but the children said I had to keep going. Friends also told me not to stop now, so I got a loan and eventually completed a master's in education at Antioch College, and then a master's in education administration at Lesley College." Kay became an education specialist and began working for the State Department of Education, traveling widely to help improve school programs. Today she is retired from full-time work, but consults on education projects and issues.

Kay never misses an opportunity to make things better. She was a founding member of Haverhill Community Action, which was started thirty-five years ago, and she still works with the group today. "Originally, I was the low-income representative on the board, and now I'm back on as the public sector person and chair of the fiscal committee." Kay has also brought her passion and faith to Calvary Baptist Church, including leading the rebuilding after a devastating fire in 1977.

Her continuing commitment to provide better housing eventually led to a formal position. "Someone, I don't know who, submitted my name, and I became the state-appointed member of the board of directors for the Haverhill Housing Authority in the 1980s. I was the first woman, the first tenant, and the first black person on the board." Kay served for fifteen years, reappointed under democrat and republican governors.

Kay's broad smile and infectious laugh are still in evidence at advisory board meetings and citizens' groups, because, at sixty-seven, she continues to work for Haverhill and for all that she believes in. In 2000, she ran for a position on the school board, and lost "respectably," by only 121 votes.

Eventually, the grace notes of life appeared. She began to travel and to take time to enjoy herself, her twenty-two grandchildren, and six great-grandchildren. In 1990, at her high school reunion in Alabama, her lifelong friend Frank Byrd told Kay that he had waited long enough; his kidding about marrying her sooner or later had come to an end. "I had no plan to remarry. When Frank came to Haverhill for a visit, my minister told me 'Kay, you always said that God would have to find you a husband, because you didn't do so well on your own. God might have sent you a blessing in Frank.' The minister was right; friendship turned to love. He became the father my children never had, and we had ten blessed years together." Frank died suddenly in the summer of 2001.

Haverhill has honored Kay many times. In 2000, she received the Liberty Bell Award, given by the bar association, recognizing all her dedication and work over the years. Kalister Green-Byrd still holds to her childhood lessons of determination, faith, effort, and service, and she has lived these truths for an entire community.

Diane Shader Smith

When you face something terrible, your soul can shrink, or you can embrace your life.

Diane Shader Smith is a dynamo. She takes on all comers at top speed. A mother, a public relations executive, a writer, and a fund-raiser, she operates from a simple premise: "Life is short, so I try not to waste a minute. When something difficult happens, I cry a lot, and then I figure out what I can do to help. I need to get a lot done fast, so I can let go and have time with my family." When Diane's world went into free fall over the course of three years, she drew on her formidable energy and her grounding in family and friends to keep going forward.

Diane's daughter Mallory was three and her son Micah was five when she became pregnant and went for a routine amniocentesis. The test showed a possibility of cystic fibrosis, but the doctor said that 99 percent of the time, the test meant nothing. "I was frantic, but everyone else said I was hormonal and overreacting." Diane was not overreacting. Blood tests showed that both she and her husband, Mark, carried the CF gene, and her baby had the disease, despite no cases in either family.

Devastated, Diane and Mark ended the pregnancy, advised by everyone that no child should come into the world with a condition still considered terminal. "A week later I was getting my hair cut and crying. My hairdresser asked me what was wrong, I told her, and she began talking about a friend whose child has CF. What stuck in my mind was that the child was not diagnosed until age six. My heart stopped. I knew instantly that Mallory had CF."

Doctors told Diane this was impossible, that Mallory would have been diagnosed long before.

"Mallory had been coming home from preschool with green mucous and a cough for months, but none of the doctors I'd taken her to suspected CF. Mark and I had a huge fight, because I insisted on testing Micah and Mallory immediately. Mark wanted to get Mallory her own independent medical insurance before we had her tested, but I couldn't wait." Two weeks later a call back to Diane confirmed her instincts. Mallory had cystic fibrosis.

Eventually, Diane realized that Mark had been correct, and now advises thinking carefully about insurance and other financial issues for any major medical problem before rushing to diagnosis.

Mark and Diane's complementary approaches to life counterbalance and support one another. "Mark is my Rock of Gibraltar. I'm drawn by connecting with people, I love to help, and I'm always working to get things done. Mark is sustained by research, he figures out what we need to do, and finds the wise path." Mark and Diane combined their gifts to come to grips with CF, and to live with the idea that Mallory has a life-threatening illness. "Improved daily treatments have prolonged life span for these kids, but this requires pounding the lungs twice a day to break up the mucous. Mark took over the job of hitting her chest, sides, and back in eight different positions. Mallory hated the treatment and used to hide before we could get started. Mark made a game out of Mallory's hiding when it was time for what he called 'pat-pat.'"

Diane searched for a book she could read to Mallory, and was amazed that there were none. "I needed something to help me explain to Mallory what she had." Diane contacted Axcan Scandipharm, a drug company that makes CF medication, and asked for a grant to do a children's book. The result was *Mallory's 65 Roses* (because cystic fibrosis is hard for kids to say, it's sometimes referred to as sixty-five roses). Diane also wrote a book for adolescents about CF, *Stevie's Secret*. Diane receives no income from these books. About 90 percent are

given free to children, and the remaining 10 percent are sold to raise money for the Cystic Fibrosis Foundation's research protocols. Diane has raised over half a million dollars for research through an annual fund-raiser in honor of Mallory.

As the family dealt with CF, Diane was diagnosed with breast cancer. Based on Mark's research, she opted for a mastectomy. In her straight-on way, Diane realized that having her healthy breast removed would virtually eliminate the chance of cancer recurring, so she chose to have that surgery six months later.

Micah presented the next family challenge. "He was in the third grade and developed some motor tics. The doctors said not to worry, but as the tics became more pronounced Mark once again went to the data and figured out that Micah has Tourette's syndrome. "It's a mild case, but it's one more thing for all of us." There were no good books for Micah either, so Diane crafted a young adult novel about a boy with Tourette's syndrome. She has gifted her work to the Tourette's Syndrome Association.

Possibly the most amazing element of this extraordinary family story is Diane's attitude. "I believe that when something happens to one of your children, you owe it to them to do the best you can in response, to inform people, to take some action, to try and make a hard situation into some-

thing positive. And I prioritize. If I have to choose between writing something about CF and cleaning the house, the house stays messy.

"Every day, if you read the newspaper, you will see that much worse things happen to children. There are always people better off, and worse off, than you are. That helps me to keep things in perspective. I have a wonderful husband and incredible kids, supportive parents and siblings, and great friends. I love my life."

Charlotte Black Elk

If there is only one Lakota woman left, she must be able to create the nation out of herself.

Growing up in western South Dakota, on the edge of the Black Hills, Charlotte Black Elk observed that many of her people were mixing outside religious practice with their tradition. "The more I studied, the more I realized that your culture teaches you your science, your religion is tied to your culture, and your culture comes out of your environment. My bones tied me to this place. This place told me how to pray, this place taught me to look at the stars, and the stars tell me when and where to be in the world. I chose to be an Orthodox Lakota."

Charlotte's Lakota name, Pte Tokahewin Ska, means White Buffalo Woman of Different Motion; a second translation would be White Buffalo Woman Who Chooses Her Own Path. Charlotte has chosen, with others of her generation, to honor her tradition by living it fully. She also chose to become a scientist, and to use modern technology to shape new ways to honor and incorporate ancient practices into tribal life.

Practicing Lakota tradition has not always been easy. After the treaty signings of the 1850s, the tribe had to focus on survival, and was not allowed a high degree of religious freedom. But the practices and ancient ceremonies have been restored to the people over the past forty years or so, as people like Charlotte have

committed to following them. "My children's generation is Lakota in a way that our people were not allowed to be in the past. Beginning in the 1960s, we raised our children to know the old ways. When I was small there was only one little boy at Powwow who sat at the drum singing with his grandfather. Today there are children everywhere, and they live as the Lakota have always lived. When we sit in prayer circle we ask that in one thousand years there will be Lakota children still living with these ways and performing our ceremonies, and celebrating life, and the life of all creation.

"We are no longer engaged in outright warfare, removal, or smallpox blankets, but the war of ideas continues. We have never asked to be part of the mainstream culture. We have a right to be who we are, and others must recognize that our way is for us. At the end of your life, it should be as though you stood on shells—the earth should not be damaged. This is our way, and what we teach our children."

Charlotte speaks around the world on the importance of following one's culture and on the teachings of the Lakota. Her talks are often anchored in one statement: Know your culture and live it. Charlotte exemplified her culture when her father died in 1982. "We can choose to keep the spirit of a person and then release it. When my father died I kept his spirit, to help me let go of my father, and to do those things he had left undone. During the time of keeping and releasing, for about sixteen months, I followed certain traditions every day. For example, I never used a knife to cut my own food; someone else had to cut it for me. I could only cut for someone else. If I was in public I did not serve myself; someone brought me food or I did not eat. By these and others practices we become more intertwined. The teaching is that every day we realize our interdependency, and that whatever goodness you give to people will come back to you when

you need it. Now that his spirit is released, I celebrate his life, and do something to honor him each time I remember him."

The sacred places of the Lakota, called the Oglala Sioux by the outside world, lie in the Black Hills on land now formally owned by people outside the tribe. "We have to ask permission to hold our ancient ceremonies where we have always held them. Our identity demands that we have the Black Hills returned to the Lakota people. The return will happen, absolutely."

When the courts refused to recognize the Lakota claim to the Black Hills, in 1980, Charlotte heard people who stated that the Lakota had stolen the land from others. "I went to our story keepers and asked how long we had we been here. They said, 'We have always been here.'" Charlotte used her research skills as a molecular biologist to verify that the legends of the Lakota are true and are proven by the geology, physics, and chemistry of the region. "We can establish, looking at the stars, when the sun was in a certain alignment thousands of years ago, and connect that to our teachings."

She has also integrated technology with tradition to meet today's needs, conceptualizing a Tribal Natural Resource Regulatory Agency for the Pine Ridge Reservation, and studying the Lakota buffalo dance ceremony in order to put

together a wildlife management program.

Charlotte is the great-granddaughter of perhaps the most famous Lakota, Nikolaus Black Elk, whose teachings were published in English as *Black Elk Speaks*. The role she has taken on as teacher and spiritual guide is not unusual for a Lakota woman. In fact, the word for woman, *winyan,* means "you are complete," while the word for man, *wica,* means "a step from complete."

"If you live in harmony with your own tradition, you will fulfill yourself. I have a private collection of my great-grandfather's letters. He writes that we are given ceremonies so that when we perform them, all generations of creation can walk the soft earth in a dancing manner. That is what I seek to do in my life."

Darlene Jackson-Hanson

When you come to a bump in the road, you have to ride it out.

Edgeley, North Dakota, population 630, is home to Fisher Flying Products, one of the world's leading providers of home-built airplanes. The chief operating officer and president of Fisher Flying, Darlene Jackson-Hanson, is an Edgeley high school graduate who went from waitress to farmwife to CEO. Darlene has a Dakota directness about her unusual history. "When my husband knew he was dying he asked me to try and run the company, and the town asked me as well, so I decided to do the best I could." If Darlene's life were a movie, the title would be *True Grit.*

After high school, Darlene and her husband, Erval Jackson, moved to a seven-hundred-acre farm, ran it together, and had two sons. Although he had no engineering training, Erv proved to be a gifted inventor. "He set up a machine shop, developed better farming equipment, and his products sold. Over time he became interested in flight, and in 1984, he became a dealer for Fisher Flying. At that time

Fisher, which was located in Ohio, made ultra-light aircraft."

As Erv's business grew, the business leaders of Edgeley asked him to consider expanding his operation and moving into town so future growth might create local jobs. Although they loved farming, Erv and Darlene wanted to contribute to Edgeley's future, so they took a giant leap.

"We broke ground for the plant in July of 1986, and in October, Erv was diagnosed with cancer. Our oldest son was twenty-three, just out of college, and our younger son was fourteen. Erv was so focused that as his illness progressed he was able to do the planning, oversee the construction, and order the inventory. He did not want to let Edgeley down, and he asked me to run the company for a year, to see if it could work. We opened the plant January 5 and he died January 9."

Those early days are something of a blur for Darlene. She does remember that a semi-trailer full of inventory arrived the day of the funeral, and the pallbearers went from the church to the plant and unloaded the truck in their suits. "At first you are just numb, and you do what you have to do. There were two experienced men in the company, the general manager and the pilot/sales manager, and between the three of us we figured it out. I had always done the books for the farm, so I knew the basics. I had to refinance every-

thing, because nothing was in my name, but I became president of Jackson Manufacturing, and we hired people and started building ready-to-flys for Fisher." Almost before she realized it, Darlene found herself in the very male world of flight.

Before long, Darlene could see that the operation was not generating enough revenue to be a success. While she was worrying, the owner of Fisher Flying products told Darlene he wanted to sell his company—to her. "I really had to think about this. I talked with the general manager and the pilot/sales manager. We wanted to survive, but I did not want to bank the farm on it. I called on an Edgeley High graduate who is a successful businessman in California and had offered to help if I ever needed it. He became the major investor, we bought the company, and moved it to Edgeley. I became the president and CEO of Fisher Flying Products. I had suddenly gone from starting a small business to running an established company with lots of customers. Remember, this was all still pretty new for me. The first time I flew was when I traveled to sign the purchase documents."

Darlene and her team got busy improving and expanding the Fisher Flying line. They now offer fifteen models, each available in a standard or quick-build kit. Purchasers lay out full-scale blueprints and build an aircraft by following detailed instructions (and probably calling

Darlene for help). Standard models require about five hundred hours of labor; quick builds come partially assembled, cutting labor to about three hundred hours. Fisher Flying sells about two hundred kits a year.

"Today, I look back and I'm surprised we've accomplished so much. We sell around the world. Our new models, the Dakota Hawk and the replica of the Tiger Moth, are especially popular." A good product, tight management, and Internet sales proved a winning combination.

When people ask Darlene how she went from farmwife to CEO, she responds that she drew on her life experience and her common sense. "You do the best you can and if you find out later it's wrong, you go ahead with new information. You can't go back and change anything in life."

In 1991, Darlene married Gene Hanson, the pilot/sales manager. Darlene has never had a desire to leave Edgeley; she finds her life there complete. She and Gene live on the farm, and they have lunch every day in the restaurant where Darlene used to wait tables. It's close to the office, and they have busy days.

Louise Serpa

I feel free in the West. Out here people like you for what you are and who you are, not what you have.

Louise Serpa was born to a life of eastern comfort, but when she discovered the West, everything changed. Now seventy-five, Louise was the first woman sanctioned by the Rodeo Cowboys Association to photograph inside the arena. Her rodeo action shots hang in museums and galleries around the world. A woman who made her own set of tough choices, Louise embodies the freedom that the West symbolizes.

Fate delivered Louise to the open range at age nine, when her mother went to Reno for a divorce and took Louise along. "Right then, I knew that the West is where I was meant to be." She managed to get back when she was seventeen, after graduation, when she worked on a dude ranch in Wyoming. Then Louise returned to the East to attempt to live the life that her family and friends expected, but her Vassar connections, a home in Connecticut, and a place in Manhattan society were simply not the right fit. At age twenty-eight, she gave it up for good and, just like in the movies, drove west into the sunset. Her first job was helping dudes with horses and teaching their children to ride. She got a small camera and started taking pictures at amateur roping competitions. She never looked back to her privileged past. "If you can learn to love living with nothing in the Mojave Desert, you are never going to leave the West."

Louise married and moved to a ranch in Oregon, where she learned lambing and all the skills needed to run a ranch. By 1959, she was divorced and living in Tucson. Photography became more

than a hobby when her younger daughter developed rheumatoid arthritis, and medical bills skyrocketed. Louise began to sell photos taken at junior rodeos for seventy-five cents each. Soon she was shooting at hunter-jumper shows and cutting horse competitions. "Grown-ups paid more."

Because she had been shooting "through the fence" for a few years, Louise was accepted around the professional rodeo, but it was a giant step when she was approved to photograph from the floor of the arena. Being both skilled and nimble helped. "You can miss a shot and be forgiven, but if you get in the way that is totally irresponsible, and you deserve to get run over." The getting run over part included being stomped by a bull and being kicked in the back by a bronco, but Louise's firecracker nature kept her coming back into the ring. Her action shots became nationally known, and she widened the appreciation of rodeo through her photographs. "Rodeo is the original American sport, and more people need to know about it." Louise's first magazine cover was "Hoofs and Horns" in 1962. She is especially proud of the trophy buckle for Best Action Photo of 1982, awarded by the Pro Rodeo Cowboys Association.

Established as a rodeo photographer, Louise extended her scope. She became the first woman allowed on the course of the Grand National Steeplechase in England, as well as the first to shoot in the ring at the Dublin Horse Show. She has worked around the world and has been profiled on television and in many magazines. A monograph of her work, *Rodeo,* was published by *Aperture* in 1994, and has just been released in Europe.

"Out here you can just do what you want to do. I shoot what draws me. Last week, I did a yearly portrait of the Tucson symphony conductor and the next day I did a portrait of a dog. I went to Montana to photograph three generations of a family that have run their ranch for over fifty years. These family-run ranches are disappearing, and I'm trying to get them in film."

With time, her photography has acquired more depth. "I'm better because I've learned so much, and I think my eye has grown as well. These days I love the action shooting because it keeps me sharp, but I'm much more interested in context and details, like hands, faces, and the interaction of people. The more I shoot, the more I see."

Louise recently moved from a remote ranch into town, onto four acres of one of the last large farm properties in Tucson. Neighboring properties are heavily developed, but she situated her house so that she looks at her two favorite mountains. "I found this property through the rodeo.

I'd heard that a friend bought the Douglas farm, and as he rode into the arena on the Grand Entry I shouted to him, 'I hear you bought the farm.' On the next circuit, he shouted back, 'Yes—do you want some?' and on the third time around, I shouted back, 'You bet!' The next day he called me, I hocked my soul and my forty acres in the country, and went for it. I am reaching a point where living thirty-five miles out of town is not a great idea."

In 1999, Louise was one of four women inducted into the Cowgirl Hall of Fame. Described as "Women of Spirit, Courage, and Leadership," members are selected because of distinguished achievements that embody the pioneer spirit, and include such notables as Narcissa Whitman and Georgia O'Keeffe. Louise has moved into town, but her spirit and courage have not dimmed. "My knees crackle in the morning and sometimes I do less than my usual two-mile walk with the dog, but otherwise, things haven't changed much. I gave up shooting rodeo for a while, but I couldn't stand it, so I started again, and I plan to keep on shooting as long as I can stay out of the way."

Jane Hines

If I say I can't help, where will they go?

Minnesota is a long way from Texas, and migrant families traveling to harvest in the far north have a hard time when accidents happen or sickness strikes. Many end up in the office of Jane Hines. As coordinator of services for Migrant Health, she has the resources and the connections to find help. But Jane brings something else to her work. For the first part of her life, Jane Hines was Juanita Mojica, the third oldest of ten children in a migrant farmworker family from Crystal City, Texas. Jane knows what it's like to "go up the road."

Because of her own experience, Jane understands what her clients face and she always treats them with dignity. "At first it's a bit formal, and they begin by saying everything is fine. But I speak the language, and I know their world. We

visit. We need to build a comfort zone. I know their families, I remember where they come from, and I keep files. So I ask about the daughter who was pregnant, the uncle who was sick. I keep asking bit by bit until I see what's really going on and what kind of help they need. It unfolds. We develop trust."

Jane remembers being in the sugar beet fields with her family when she was ten, and the farmwork was all done by hand. She and her siblings were expected to live this life as adults, but Jane made a different choice. "My mother had been forced to leave school after the ninth grade, and she was left with a hunger. She kept saying to us kids, 'Study, stay in school.' Migrant kids leave school in early spring to go north, and don't return till late fall, so getting enough credits to graduate is difficult. Because of my mother I felt supported in completing high school, which I did only a year behind my class. Then I got a job as a bilingual nurse's aide for a new clinic in Crystal City, and I stayed there when my family went north the next two years. I liked the work but I missed my family."

Because separation was so difficult, Jane migrated north with her family the next year, but when they reached Wisconsin her father realized she had changed. He suggested she look for work in a hospital. Jane found a job she liked, made

friends, and decided to stay in Wisconsin, finally accepting that she would live far from her family. She became a licensed public nurse (LPN), married, and moved to Minnesota.

"I had three children and stayed home to raise them. Sometimes I saw migrant families in the area, but I didn't get to know any. I was living a settled life." In 1975, when her youngest child was four, a severe flood wiped out crops and dislocated migrant families, who were taken to the Moorhead College gymnasium. Jane was called in as a translator, and she volunteered more

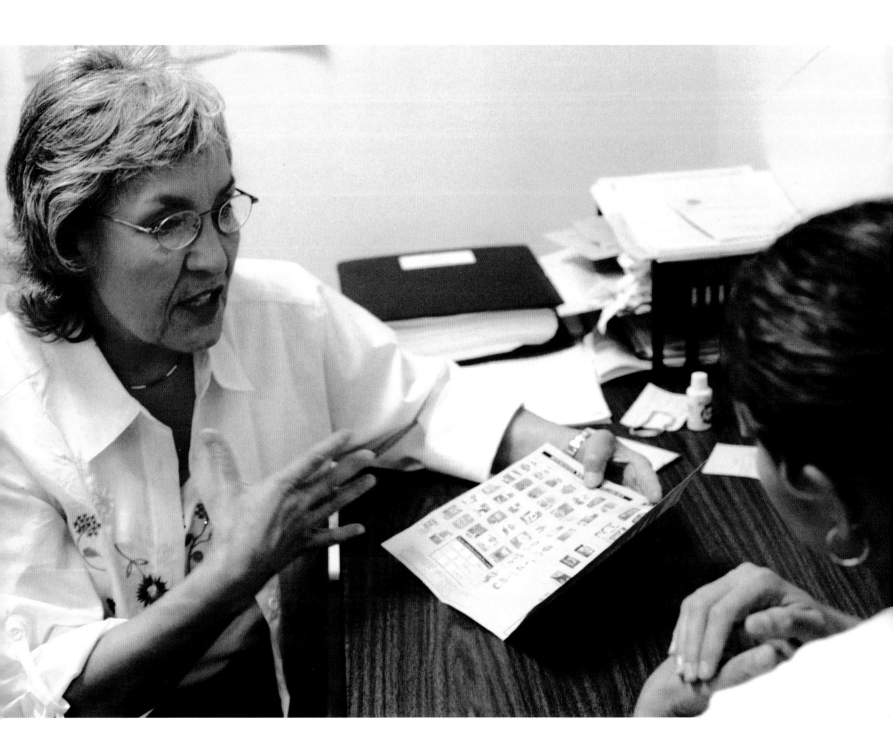

time to help. "I knew what they were going through, and there were so few people who could even speak their language, let alone help them. I wanted to do more." When her son started first grade, she applied for a part-time job, "just planning to do a little." A little became a lot. Jane was a natural for the Migrant Health Service. Today she coordinates all patient care and directs the Women and Infant Care (WIC) program.

Whatever the families need is what Jane does. The WIC program focuses on prenatal health, for moms and babies. "As we prepare for the birth, I get to know them. So then if a pregnant mom doesn't turn up for a checkup, I know her relatives, and I can find her. I try to think way ahead, especially for teen moms—what are they going to need? How will they get care?" New moms bring their babies to Jane, who waltzes around the office showing them off. Her enthusiasm is one reason everyone likes to stop in and visit with Jane.

Jane's coworkers and the migrant families can count on her to always be available. Her 800 number is well known along the Great Plains migrant stream, and her phone rings constantly with calls from people from Minnesota to Texas.

A big part of her job is coordinating services as families travel, and identifying social workers, agencies, charities, and other resources along the way. "We had a family where the mother developed breast cancer. They had very little English, and no resources. I went with her to do the paperwork, and worked with the hospital to find community care funds so she could be treated. Then the husband, who was working at a dairy, slipped and injured his back, so I needed to find help for him. After the treatments they wanted to go home, so I typed up all the health information for the next doctors. Halfway home the car broke down; they called me from a motel and said they thought they were in Missouri but it might be Kansas. I got on the phone with the motel clerk and found a social worker in that town, and that social worker got a garage to fix their car, and finally we got them home. These people were in dire need, they had three little kids, and things just snowballed."

In 2001, Jane was named a Blue Cross–Blue Shield Champion of Health. The director of Migrant Health nominated her; she was one of twenty-five people selected from five hundred nominations. The award astounded her. "I felt guilty. This is just what I do every day. I get paid to help people. I've been told that I can't help everybody all the time, but at least I can try."

This book was set in Garamond 3, Trajan, and Type Embellishments.

Book designed by Junie Lee Tait